Caring for Japanese Arts at the
Chester Beatty Library

Yoshiko Ushioda

CARING FOR JAPANESE ARTS AT THE CHESTER BEATTY LIBRARY

MY HALF-CENTURY IN DUBLIN

Translated from the Japanese by Etsuko Kanamori

DALKEY ARCHIVE PRESS

Originally published in Japanese as *Dublin de Nihon bijutsu no osewa o: The Chester Beatty Library to watakushi no hanseiki* by Heibonsha Ltd., Tokyo, 2014

Library of Congress Cataloging-in-Publication Data
Identifiers: ISBN 978-1-62897-184-2
LC record available at https://catalog.loc.gov/

www.dalkeyarchive.com
Victoria, TX / McLean, IL / Dublin

Dalkey Archive Press publications are, in part, made possible through the support of the University of Houston-Victoria and its programs in creative writing, publishing, and translation.

Printed on permanent/durable acid-free paper

With deep gratitude to my sister-in-law, Kazuko Yamamoto, for the tremendously generous support for the project.

Yoshiko Ushioda

Table of Contents

Foreword

Among Irish people, and those of Irish descent, there is considerable interest in the experiences of Irish migrants and the formation of émigré communities in all continents. This is reflected in popular demand for books, and indeed for feature films and for radio and television documentaries concerning the Irish Diaspora, both past and present, and their associated history, literature, culture and social geography. Recently, such interest has found a corollary in studies and media features concerning those who have migrated into Ireland and their experiences, particularly over the past twenty years. Therefore, this book presents a most timely and exceptionally significant contribution to this field. It provides us with the perspectives and perceptions concerning Ireland and its people that had been gained by the first Japanese to migrate and settle permanently in this country, Satoshi and Yoshiko Ushioda. Over the past fifty-seven years in Ireland, they raised their family, facilitated the emergence of an Irish-Japanese community, and contributed immensely and inspirationally to Irish scientific, academic, artistic and cultural life.

Yet this fascinating book also provides much interesting insight for artists, art historians and cultural commentators, and for all who love and appreciate the fine arts. At its core is Yoshiko's memoir, which reveals not only how she contributed so much to the work and profile of the Chester Beatty Library in Dublin, but also how much she learned about her own native cultural and artistic traditions through her loving care, curatorship and attention to its oriental and particularly, its Japanese art collections. Her account adds further enrichment to our understanding and appreciation of the library's treasures,

and to its invaluable service and significance to Ireland and to the world.

In certain respects, the life experience of Yoshiko and Satoshi Ushioda, and their contributions to Irish-Japanese relations, may remind us of the Graeco-Irishman, Patrick Lafcadio Hearn *alias* Koizumi Yakumo. He had settled and married into Japanese society during the late nineteenth century, and he contributed to Japan's emergence on the international stage through his important and influential literary and cultural legacy that explained Japanese society to the wider world. Yoshiko Ushioda's memoir, already a bestseller in its original Japanese version, provides a brilliant interweaving of her personal, professional and cultural experiences. It offers unique insights into how two island nations, respectively located on the Pacific and Atlantic rims, share certain common traits and experiences that find expression through consideration of others, generosity and exquisite artistic creativity. Through these qualities they engage the world's imagination.

Declan M. Downey, Ph.D. (Cantab.),
Corresponding Member of the Royal Academy of History, Madrid,
University College Dublin, School of History,
Trustee of Chester Beatty Library (April 2012-May 2017)

Introduction

On March 14, following a last farewell party at the Gajoen Hotel in Meguro, Tokyo, with my parents, relatives, and friends, we headed for Haneda International Airport. This would be my very first time flying, and I would be taking my eighteen-month-old son, Kazuaki. I was daunted by the prospects of travelling on our own. Our travel agents had looked after us well, and we boarded the Air France jetliner and were seated in the first row. They had arranged for us to travel with Dr Nagata—a noted scientist who had been the captain of the Japanese Antarctic Expedition. There were very few Japanese passengers on board, but my nerves were dispelled by Dr Nagata's friendly warmth. Kazuaki fell asleep soon after the plane took off from Haneda. After six hours we landed at Anchorage International Airport, which was covered in ice. I was swept away by the cool and calming view of ice-covered mountains silhouetted in the low morning sun. We had breakfast in a cafeteria, and both Kazuaki and I enjoyed the meal without feeling particularly tired. The waiting room in Anchorage was quite warm, and I relaxed and had a pleasant chat with one of the ground hostesses. She was kind and gave Kazuaki a little toy and chatted to him. With a fresh crew, we re-boarded the plane. It must have been unusual for French and Japanese flight attendants to have a Japanese toddler on board. They gave him a lot of attention at every opportunity. Shortly after we were airborne, we started to doze off, and then were woken

by the lunch service. I no longer had any sense of time or day, and really enjoyed a brilliant full-course French dinner. A few hours passed, I read some weeklies, and Kazuaki slept again. There was an in-flight announcement that the plane would fly on to Hamburg instead of the planned stopover in Stockholm because of adverse weather conditions. Dr Nagata kindly translated all the announcements throughout. In the waiting room at Hamburg Airport we had tea. Through the window, I saw tidy rows of houses with red gabled roofs, which were quite impressive. A few hours later we arrived in Paris as scheduled. This was Dr Nagata's destination; I thanked him from the bottom of my heart. As we parted, he patted Kazuaki on the head and wished us a safe journey. Tears welled up in my eyes as he had been so good to us and would now no longer be there. I owed a great deal to him for helping an insecure young mother and her son on their first air journey.

This is an entry in my diary from March 1960. My life in Ireland started this way, over half a century ago.

The purpose of our journey was to re-join my husband, Satoshi Ushioda, who had already moved to Ireland six months earlier. Having received a warm send-off from my parents, relatives, and friends, my son and I boarded the plane bound for Paris. At the time travelling abroad was not easy—there were a lot of restrictions and Haneda International Airport was quiet with few Japanese travellers in sight. While I was excited about reuniting with my husband after six months apart, I was still anxious about travelling by air for the first time as well as going abroad and bringing a toddler. Nevertheless, the kindness offered to me by a number of people made this all happen.

Having taken the decision to travel to Europe, I put my full trust in the Hanshin Air Travel agency, which had also

taken good care of my husband when he departed Japan. They made all the arrangements, including applying for a visa and purchasing plane tickets. On the day of my departure, some staff from the agency met Kazuaki and me at the entrance in Haneda Airport to handle the complicated procedures for embarkation, luggage check-in, declaration of unaccompanied goods, etc. Furthermore they had thoughtfully arranged to have us seated in the front row beside Dr Nagata and made the introductions. Dr Nagata was so kind and helpful, and welcomed us warmly. He translated the in-flight announcements throughout the journey. When we disembarked in Anchorage, he also took my hand luggage and escorted me as I was fully occupied carrying my sleeping son.

In the waiting lounge at Paris, Kazuaki ate well and was full of energy following a sound sleep during the flight from Hamburg. I struggled to keep up with him as he waddled happily all over the place. A smiling Japanese ground hostess approached him and gave him a little toy with some kind words; this seemed to settle him down. It seemed that not just during the flight, but in a French airport, the sight of a Japanese child was unusual in those days, so everyone, men and women of all ages, and from different countries, talked baby talk to Kazuaki. Their genuine gentleness and kindness with Kazuaki helped ease my nervousness slightly during the journey.

> After two in the afternoon, our plane touched down in London Airport under a heavy grey sky. It felt gloomy and bleak on a chilly day in mid-March. My heart pounded with the anticipation of seeing my husband after six months of separation. I proceeded to go through the various stages of the disembarkation procedure, trying to suppress the release from tension that might break out in tears at any moment. A kindly Japanese businessman offered to carry my luggage. He said he was on his way to Glasgow, but I could not even

make conversation. I just bowed and said thank you. At
the counter I handed over my landing card that I had
filled out during the last stage of the journey, but could
barely manage to answer any of the questions. Finally
we went through to customs, after which my husband
came into sight. He initially seemed distant compared
to when we had said farewell to each other at Haneda
half a year previously. But that impression changed in
a moment and was replaced by his beaming smile, and
he hugged Kazuaki closely. Our son stared at his father,
with mystified eyes on the verge of tears. I, finally free
after passing through customs, collapsed into tears, and
there was a great wave of relief from all the tensions and
stress that I had carried throughout the long journey. My
husband, clearly accustomed already to living abroad,
seemed so steadfast, even dazzling to my eyes. With
him stood Mr Ichiro Otaka, a friend of ours, who had
been sent by the Japanese Ministry of Foreign Affairs
to study at Oxford University. We headed for our hotel
in the city of London in Mr Otaka's car. Kazuaki slept
in his father's arms. My impression of the first time in
London was the view of orderly brick houses with their
chimneys sending up vigorous plumes of smoke. In the
car I gave my husband all the news from home and told
Mr Otaka how his own family were getting on. As dusk
turned to night, we arrived at the hotel. Satoshi and
I saw off Mr Otaka as he set off on his drive back to
Oxford after promising to meet again soon. Kazuaki,
who had fallen asleep at the airport, kept on sleeping
until midnight. He must have been exhausted and we
felt slightly sorry for him. We were ourselves exhausted,
and had no energy but to whisper updates on what had
happened while we were apart. I was so full of deep
emotions that we were finally all reunited again. After a
light supper we went to bed.

In London Airport where I finally landed on a chilly dark March afternoon after changing flights a couple of times, my husband was waiting for me; he had been working for six months in the University College Dublin as an invited fellow of the Imperial Chemical Industries (ICI) from Tokyo University. He marvelled at how quickly Kazuaki had grown. Kazuaki seemed to be about to burst into tears any moment in the arms of his father, while I was already in tears at the relief.

The view of London through our hotel room window was strange to me, a forest of chimneys with dark smoke billowing upward from countless fireplaces. From the heavy leaden sky, sleet started to fall. "Is this a typical winter view of London?" I wondered and felt downcast for a moment, but then the joy of our reunion soon took over. Every motion and babble that Kazuaki made was new and delighted Satoshi; he lifted him high again and again. Kazuaki must have thought of him as a strange, friendly man, and bore it with an awkward look on his face.

On the following morning, still dark with low clouds, we had breakfast. The milk tasted richer and cornflakes, which both Kazuaki and I had for the first time, tasted good. Over the next two days my husband, despite a slight cold, showed us around London. Kazuaki was so excited at the sight of the red double-decker buses that the first thing we bought was, of course, a toy double-decker. He liked it so much he held it in his hand all the time, even as we boarded the plane to Ireland. We took a taxi to the air terminal in London from which bus services were available to the airport. Waiting for us there was Dr Susumu Kamefuchi, a Japanese theoretical physicist. While we waited for the bus to leave, we had a pleasant chat over afternoon tea about the latest news

we had from Japan. Dr Kamefuchi was a researcher at Imperial College and he told us that he would be visiting Dublin's Institute for Advanced Studies frequently. We promised to meet again before departure.

We were finally on our way to Dublin on a small-sized British European Airways plane. All the disembarkation procedures went very smoothly. The sight of an Oriental toddler seemed rare to quite a few people there and they made us very welcome. I felt quite emotional as my feet stepped onto Irish ground, where a new chapter of our life would begin together. Dr Dervilla Donnelly, a colleague of my husband's from UCD, greeted us at the airport, and we all headed for our new home in her car as night fell on the city. We travelled for some time through beautiful leafy residential areas and along tree-lined coastal roads. We finally arrived at our new place in Monkstown in the suburbs of Dublin. It was a quaint, red brick house furnished with well-polished heavy mahogany furniture, colourful patterned carpets, velvet curtains, and a matching sofa set—I had never seen anything like it, except in films. The dignified feel of that house gave us great comfort and rest after a very lengthy journey.

My life in Dublin began at this house, and after a while, I would come to encounter the Chester Beatty Library.

Caring for Japanese Arts at the
Chester Beatty Library

Chapter 1

The Beginning of Our Half-Century in Ireland

IN 1959, THE YEAR before we moved to Ireland, we were living in an exclusive residential area in Tokyo, renting a first-floor apartment. The rent was a bit beyond our income. While taking care of my son, who had just turned one, I stayed at home and took on work proofreading school textbooks sent from Sanseido Publishing Company, where I had worked before I got married. My husband, having received a doctoral degree, was continuing research at Tokyo University while working as a laboratory assistant. In addition he was teaching part-time at a private college in an attempt to make ends meet. The reality was that we were in a harsh situation, and received financial aid from his father to pay the rent.

At this time, many of his friends with a similar degree aimed to study in the United States. Naturally, my husband thought about following the same path until his principal professor suggested, "Dr Ushioda, why don't you think about the option of studying in Britain?" This sufficiently interested him, as he was fairly fluent in English. The professor was familiar with the UK, having spent a few years at Oxford before the war. It was October of the same year that Satoshi received the news that he had been offered a job at University College Dublin (UCD) as a fellow of the UK Company, ICI. It was common at that time for researchers who studied abroad not to take their families along, so I saw him off with a hope to join him at some later stage. Until we come to that, I would like to describe our circumstances in a little more detail.

The first-floor apartment we were renting in the Denen-Chofu area of Tokyo was owned by the Otakas, a diplomatic family famous since the pre-war period. The owner, together with his wife, had retired from the position of ambassador when the war ended, and three of their five sons were working as diplomats. Sharing the same roof with such a family gave us some valuable insights into life. In addition, they were related to Mrs Yuriko Onodera, author of the book *Barutokai no Hotorinite* (On the shore of the Baltic Ocean). Her husband had served as the army attaché, and she had lived abroad for a substantial period of time. I'm sure that living on such friendly terms with them greatly influenced our decision to live abroad. They had wide experience of living in Europe and said to me, "Mrs Ushioda, spending some years abroad when you're young will give you invaluable experiences." At the time, the third son of the Otaka's was studying at Oxford, sent there by the Ministry of Foreign Affairs. Mrs Otaka happily assumed we would go there to visit her son in London. Both Mrs Otaka and Mrs Onodera had some empathy for a young mother who might feel anxious about rearing children abroad, and provided some encouragement, saying "Child rearing is the same no matter where you live in the world. What is important is to show your child an abundance of love and to take any kindness offered to you." They added some practical advice, such as the kind of kimono and accessory that would be appreciated at social occasions overseas. Of course there was quite a difference between their world of diplomats and ours in academia. But they were the best advisors I could have had at the time. And in fact the kimonos I brought according to their advice did prove to help me dress for numerous occasions and allowed a natural opportunity for conversation even though my English was poor.

So it was in March, 1960, six months after my husband had left for Dublin, that I left Haneda with my eighteen-month-old son, and with a mixture of insecurity and excitement. It was my

first journey abroad, and was made successful with the kindness offered by so many people, both friends and strangers.

The first residence we took in Dublin was on the ground floor of a red brick house situated in a residential area. It was a furnished flat that one of my husband's colleagues had found in time for our arrival. The owner was a beautiful old lady with physical disabilities, and she lived on the first floor with an in-house maid. Even though our flat was small, it had a conservatory and a big lawn at the front and back, and there were some apple trees. It was an ideal place to bring up a child, and additionally the maid helped me whenever a need arose. What we appreciated most was that she babysat whenever it was needed. There were many times my husband and I were invited together to an event, something that was rare back in Japan. Of course it was hard to leave a small child at home, so Frances, the maid, saved us many a time.

In those days there were only two other Japanese living in Dublin, and they were studying at the Dublin Institute for Advanced Studies (DIAS). They came to our place frequently. These physicists, together with my husband, a chemist, used to have fun and engage in lively discussion, while I prepared dinner in the kitchen. I still remember Kazuaki sitting with them, absorbed in playing with his Meccano set. It had been a present from one of the theoretical physicists, Dr Kamefuchi, and he helped Kazuaki every now and then.

For Satoshi, work was going smoothly after the six-month transitional period he had spent alone. According to him, he rarely had difficulties delivering lectures in English as he could refer to chemical structure formulae written out on the blackboard.

Financially too, our life here was better than it had been in Japan. For example we were paying half the rent we had been in Tokyo, and were able to afford a flat with a garden. Looking back now, even after Japan had crawled back from the ashes

of world war defeat, it was still in need of various things, and a housing shortage was a serious issue. Compared to that, we were very fortunate living in Dublin as a young couple. Food brought a lot of surprises at the beginning, and I had no choice but to switch to Western cooking, which in fact went rather well. There were no supermarkets in those days, and I had to use my poor English even to buy a loaf of bread or a bottle of milk. Having been used to the decimal number system in Japan, I would ask the shopkeeper for five eggs. He would reply, "Can you make it six?" When I asked for ten, he would reply, "Twelve instead?" I really felt I was living abroad. I later realized that shopkeepers followed this system in order to simplify food prices. This was just one example of the many surprises and difficulties I encountered that I hadn't imagined when coming from Japan. Nevertheless, it didn't take long before I became accustomed to the life here, partly because I was still young.

I owe a huge amount to the generous time and assistance offered by our kind friends and acquaintances. Taking turns week by week, the wives of my husband's colleagues used to invite Kazuaki and me to their place. They taught me to cook, bake, knit, and embroider as the children played. Looking back at my own childhood, dominated by the war years, I realized that my life had been far from such homely domestic events. The only memory of this kind of thing I could recall was from well before the war, in my Anglican nursery days when English lady teachers would bake delicious biscuits for us and embroider beautiful needlework patterns for cushion covers. Who would have thought that a girl, brought up like that, would someday move to Ireland and receive personal tuition in baking and needlework from Irish, English, and Scottish ladies!

Gradually changes came about in this rather peaceful and calm life I was enjoying. At this time there was no Japanese embassy mission operating in Ireland, and there were not that many Japanese visiting Ireland, but they were increasing little

by little. And we welcomed a new arrival too: a baby girl was born! Dr Kamefuchi, the physicist I mentioned earlier, bought two books to find for our daughter a good Irish or English name that would make some sense in Japanese as well. As a result of his research, he came up with Ema; Eimear, or Emer, which was a very common Irish name; and Emma, popular in the UK. We finally picked Ema in consideration of the Chinese characters which would match the pronunciation. My husband was concerned that Emma could mean "the Buddhist King of Hell" in Japanese, so one 'm' was dropped. For Ema, we decided to assign Chinese characters meaning "blessed with linen," which nicely tied in with Ireland. Ema was once told by her Montessori teacher that her name was misspelled, but otherwise grew up without problems and is now teaching applied linguistics at Warwick University in the UK.

Ema recounted an interesting story a few years ago. She had a Masters graduate student at Warwick who came from Chile. According to the student, Ema's name was spelt the same way in Spanish too and, moreover, in Chile they even had a wine called Santa Ema! Early in the New Year, the student knocked on Ema's office door and presented her with two bottles of Santa Ema wine, one red and one white. Apparently, the student had instructed her boyfriend to bring them over from Chile when coming to visit her in England at Christmas! Ema brought the two bottles of Santa Ema wine to Dublin as a gift to her father, who's also very particular about wine. These bottles, now empty, are still on display at home, and they provide an interesting conversation piece. Naturally we shared the story with Dr Kamefuchi, Ema's godfather, who was delighted at this further development to the name he had suggested so many years ago.

I apologize for wandering somewhat from the story of how our small Japanese community in Dublin helped each other so that we could lead life together as a big family. Supported by extremely warm-hearted Irish people, we led a life which was

comfortable to the point that we almost forgot that we were abroad. Some twenty years later when Mr Ryōtarō Shiba, a well-known Japanese writer, interviewed me, I told him that I had never had an unpleasant experience living in Ireland. He was very impressed. And it has remained true for me ever since.

Chapter 2

My Encounter with the Chester Beatty Library

IN MARCH 1960 THERE was no Japanese embassy in Ireland, and indeed the only other Japanese living in Ireland were a couple of physicists. Our life in the initial stages was supported by my husband's colleagues and their families, who were kind to me and took turns offering lessons in English, cooking, child-rearing, knitting, and even embroidery. Contrary to my concerns about leaving Japan, I was far from anxious about living abroad and led five fun-filled years as a housewife.

You might wonder why Japanese physicists were living in Dublin in those days. The reason was that they were working in the Dublin Institute for Advanced Studies. And more Japanese scholars who were studying in the UK also paid frequent visits to the Institute.

The Institute had been established in 1940 by the then Taoiseach (Prime Minister) and later President, Éamon de Valera. Dr Albert Einstein was, as you know, a famous physicist who fled to the US to avoid persecution by the Nazis before the start of the war. I wonder how many of you know of Dr Erwin Schrödinger. He was prominent in the fields of quantum theory and wave equations. He had fled to Dublin as he opposed the Nazi oppression of Jewish researchers. As a mathematician himself, the Taoiseach welcomed Dr Schrödinger as the director of the Institute. Dr Schrödinger took up residence in Dublin in 1939 and spent the next seventeen years there, welcoming numerous scientists from all over the world before returning to Austria. Even after Dr Schrödinger retired, researchers were

accepted from across the globe, two of them being Japanese
physicists from Nagoya University. They had come to live in
Dublin a few years prior to my husband. Even now, some fifty
years later, the Institute accepts physicists from Japan on a
regular basis.

In 1965, when working at UCD, my husband was fortunate
enough to receive an invitation to be a postdoctoral research
fellow at Harvard University, joining a synthetic chemistry
research team led by Professor Robert Woodward. He was a
prominent figure in the scientific world, and famous for the
enthusiasm and dedication he brought to his experimental
work, supervising fellow researchers, and running seminars.
My husband, anticipating the degree of commitment expected,
found an apartment within walking distance of the laboratories.
At Harvard he totally devoted himself to the research of
synthesizing organic compounds, and it became routine for
him to go back to work at around 8pm, having taken only a
short break at home for supper. In 1965, Professor Woodward
received the Nobel Prize in Chemistry, a solo laureate for
his contributions to synthesis in organic chemistry. For my
husband, the joyous pleasure of taking part in the celebrations
with him has become a lasting memory.

My husband worked very long hours at the laboratory, and
was only home on Sundays. He spent time with Kazuaki and
Ema, who were aged seven and four then. The little ones didn't
seem to have any complaints or show any feelings of being out
of place, and happily started going to a school and a nursery in
the neighbourhood, soon becoming accustomed to life in the
United States. I also made new friends, not just from Japan, but
also from other countries, as this was a college town. The city of
Cambridge hosted two universities, Harvard and MIT, and its
streets with their variety of students and people from all parts of
the globe had a cosmopolitan feel, unlike its bigger neighbour,
Boston. I was fortunate to be able to make good use of my time.

The first place I visited was the Fogg Museum on the campus of Harvard; I found myself enraptured by Japanese artworks that I was seeing for the first time in my life. Having spent my schooldays during a time of war, followed by its aftermath, I had had very little chance to visit museums or galleries that might have fostered a love of art. I went back to this museum time and again, and found myself deeply moved by the exhibits. Before long a gentleman noticed me and started to talk to me gently— in Japanese! This was Professor J.M. Rosenfield, a specialist in Japanese art. He took the time to give me a guided tour through each one of the exhibit rooms, explaining the details of each Japanese scroll and painting. I was electrified at the sight of such a large body of Japanese art that I knew nothing of. He added that Boston Museum, which was not far from Cambridge, housed a large collection of ukiyo-e prints and Japanese picture books. Some of these works were of such excellent quality that they would, in Japan, be designated national treasures, yet they were held in underground storage in Boston. Spurred on by his remarks, I visited Boston Museum several times, and indeed the collection was so huge that I spent my time only with the ukiyo-e, to my regret.

Life in Cambridge was a rich experience for us. For me especially the enjoyment of seeing these collections in the museums became a pointer for my later life.

In 1968, with my husband's fellowship at Harvard drawing to an end, we thought about the option of returning to Japan. There was a lot of student unrest in the colleges and universities in Japan at this time. Senior staff from Tokyo University advised that we would be better off staying abroad a little longer, as the current situation didn't allow researchers to focus on research. For that reason we made the decision to return to Ireland, where Satoshi resumed his work at UCD. His colleagues and their families welcomed us back with open arms, and we took

up our comfortable life again. For my husband, it was almost a holiday, a chance to recover from the extremely long hours and hard work he had put in at Harvard.

The year before we had moved to the US, a Japanese embassy was opened in Dublin, staffed by a deputy ambassador, secretary, and a few Irish staff. When we returned to Ireland, the ambassador had left, but the secretary, Mr Fumio Takeuchi, and his wife, whom we had met before we left, were still resident.

Our involvement with the embassy revolved around establishing an Ireland Japan Cultural Association, IJCA. Japanese residents in Ireland at the time were, in the main, students studying Anglo-Irish literature. We also had some people from different fields living in Ireland—such as Karate instructors. The IJCA was formed from a few dozen original members, comprising a small number from the Japanese community and Irish people who took an interest in Japanese culture and art. Some of them had lived in Japan for business, including a Reuter's journalist who had covered the Far East. My husband and I were active in proposing and launching different activities, and my husband was appointed as a member of the steering committee. Later the IJCA would merge with the Ireland Japan Economic Association and be renamed as the Ireland Japan Association. The IJA is still active in Ireland today.

In 1970, as one of the first IJCA activities, a Japanese language course was launched. The association asked me to be the instructor. It was a weekly two-hour lesson. The students came from a variety of backgrounds, and were mostly well-educated adults with a sprinkling of younger students. Amongst the group were a Gaelic college teacher and a few housewives who had mastered other European languages. The wife of the deputy minister of culture also took the course, and her attitude to the challenge of a new language was impressive. As well as this course I was asked by the Ministry of Foreign Affairs to give language lessons to some young diplomats. After a few sessions,

I found that some of them were unable to attend because of pressure from other official duties, so I made up for this by running extra lessons at home. Later, one after another, four of this group were assigned to the mission in Japan. They were greatly appreciative of my services and the extra lessons.

As for the original IJCA language course, I got help from Japanese students whenever there was a boost in the number of students taking the course. For a few years, Father Frank Purcell lent a hand as well. He was a priest of the Society of St Columban, and had stayed for a long time in Tokyo, where he had taken Japanese lessons at a language school. He was ideal, you might even say heaven sent! I owe him a great deal that I was able to continue teaching at a reasonable pace for a much longer period of time.

One day I received a phone call from the Japanese embassy, asking me to get in touch with a British lady who had an urgent need to learn Japanese. I called the lady, Ms Jan Chapman, and she explained the reason for the urgency.

Though the Chester Beatty Library had been open to the public since 1954, and Chester Beatty himself had died in 1968, various preparations for curating and exhibiting the collections had been underway since the library opened. Jan was one of the first two curators to be employed by the library, and though she had majored in Chinese arts, she was asked to arrange for the Japanese collections to be catalogued. The other curator, also a graduate of Durham University, was put in charge of Islamic culture. To my surprise, Ms Chapman mentioned that she had never learned Japanese.

On the very next day I visited the library in response to her plea to start lessons as soon as possible. She surprised me further by asking that I teach her Japanese while she continued the catalogue work at the same time. The only way to realize this would be to sit next to her and work on cataloguing together for whatever time permitted. After giving the matter some serious

thought, I made the decision to work with her and made an arrangement for her to attend the IJCA lessons as well. This is how I came to work for the CBL as a volunteer. As I look back now, it was a single phone call from the embassy that changed the entire course of my life and my family's.

After returning to Ireland from the US in 1968, I heard that the state funeral of Sir Alfred Chester Beatty had taken place at St Patrick's Cathedral in Dublin on January 29 of the same year. It was supposedly the first time in Irish history that a foreign national received a state funeral. Sir Chester Beatty would spend every winter in Monte Carlo, escaping the cold weather. He passed away at the Princess Grace Hospital on January 19, three weeks before his ninety-third birthday. He suffered from silicosis, a hazard of the mining business he was in, and which would bring him his fortune in later years. Despite an earlier, dire prognosis from his doctors, he had lived a full life for ninety-three years.

After his death, his body was transported by air to Ireland and following the state funeral at the cathedral, he was buried at Glasnevin Cemetery in Dublin. In according him a state funeral, the Irish government expressed its utmost gratitude to Sir Chester Beatty and the great cultural heritage he had presented to the state.

As early as 1950, Beatty had already presented his collection of Western paintings to the National Gallery, and in 1953 he had distributed his collection of military artefacts, including samurai swords and arquebus, to the Military Museum. As mentioned earlier, his library opened in 1954, and it had been extended in 1957.

Beatty's will stipulated that his library was to be bequeathed to the Chester Beatty Library, and that the Irish government was to maintain the library and museum to house and exhibit these assets to the public as well as draw up a complete catalogue

of the collection. To respect these terms, the government drew up the necessary laws relating to the management of the CBL through the Offices of the President and Taoiseach. In accordance with these laws, a board of ten trustees who had been named in his will, and who were drawn from the legal, academic, and business fields, was established to manage the CBL. The cost to fund all of this was enormous and the Irish government could hardly afford the expense. Nevertheless, the government adhered to the terms of the will and employed two curators. In September of 1968, the Chester Beatty Library, situated near Sir Chester Beatty's residence, where he had enjoyed showing friends and guests his collections, had a reading room opened for scholars. This was in accordance with his will, and it involved the construction of one additional floor to a building with a small storage facility. This had taken place two years before I became involved with the library.

Chapter 3

My Neighbour, the Father of Hockey in Japan

I WOULD LIKE TO write a little more about our early days in Dublin, dating right back to 1960, ten years before I knew anything about the Chester Beatty Library.

A new chapter in our life following a six-month separation began in a quiet residential area on the outskirts of Dublin. It was a summer Sunday when my husband, having purchased our first family car, second-hand of course, was happily washing it in the driveway. Owning a car was an unthinkable luxury in Japan in those days and the black Morris Minor was literally my husband's "pet." Kazuaki was romping around the lawn, piping up "Papa Mo-Mai." A short old gentleman walked up, stood beside my son with a smile on his face, and said to my husband, in perfect Japanese, "You shouldn't work on Sundays." My husband called me over, and we set aside our chores to chat with this impressive, smiling gentleman who had fluent Japanese. To my surprise he, Mr William Gray, lived with his wife in a small cottage across from us. He was a retired Anglican minister and explained that he and his wife had lived in Japan before the Great War.

After this first encounter we became very close, and a family-like friendship began. I cannot begin to express how much comfort we received from the couple when there were so few Japanese in Dublin.

Mr William Gray was born in Ireland in 1875, and after graduating from the School of Divinity in Trinity College

Dublin, he moved to Japan in 1905 and stayed in Tokyo until 1914. During this period he married Miss Sophie Mary, then a student of the University of Sacred Heart in Japan; her parents were also missionaries. After their wedding, they spent their honeymoon in Nikkō. Mr Gray showed us photographs from the period; it made him happy to tell us of their memories of the time they spent in Japan. As a keen hiker, trained in the high peaks of Switzerland, he often climbed the Kamikochi Mountains in central Japan. He was a friend of Mr Weston, a famous English missionary and mountaineer, allegedly known as the godfather of the Japan Alps. He had so many memories of these times, and it made him so happy to recollect and retell the stories. After returning to Ireland, and with the intervention of two world wars, he had lost touch with his friends in Japan; he and his wife were somewhat lonesome, and, as he put it, were gathering the cut threads of their memories.

Apart from the friendship of our newfound neighbours, another pleasure of mine was to read the *Weekly Asahi* magazine that we had sent over by surface mail. Starved of anything in Japanese to read, I would devour each issue from cover to cover. One day I came across an article entitled "The Benefactor of Sports." One of the questions posed was, "Who is the benefactor of hockey in Japan?" The answer it gave was the "late Mr Gray, an English minister working in St Andrews Church in Iikura, Minato Ward, Tokyo."

"Could that possibly be our neighbour, Mr Gray?" we wondered. Only half believing it might be true, we visited him to find out. "That's me!" he replied, and his crumpled face was full of tears—something I can't forget even now. Over the next few days I wondered how to inform people in Japan, and I decided to write a letter in the first instance to the editors of the magazine.

"I'm a subscriber to your magazine, receiving them in Ireland by surface mail. I expect this might be a slight shock to you, in

regard to an article you published some time ago. I'm taking the liberty of informing you that Mr Gray is still alive." This letter generated a huge amount of interest in Japan, and I, together with my husband, were somewhat bemused.

From the many people in Japan who had heard the news, a flood of letters started to arrive through our letterbox, and kept on arriving. Armed with these letters, I visited Mr Gray. He received me, and when he saw them, he could not utter a word, and just held me in silence. In my letter to the magazine editors, I had offered to translate any letters sent to Mr Gray; there were days when all I could do was to spend my time in translating the mound of letters. They were sent not just from people who had known and played hockey under Mr Gray, but people who had joined the club in later years and had come to love the sport. Even one hundred years after Mr Gray departed Japan in 1914, there were people who still remembered his legacy; I felt keenly content that I had written that letter to the *Weekly Asahi* magazine then. Mr Gray, whom all had thought was dead, was alive; I felt that there was more than a coincidence in what had ensued when he started his conversation in fluent Japanese.

Mr Gray, in his early thirties in 1906, introduced hockey to the students of Keio University—this is commemorated as the origin of hockey in Japan. Mr Gray explained that he had been an active hockey player at Trinity College. He had encountered many difficulties in Tokyo when starting the hockey club. Their very first game was against a foreign club in Yokohama, and Mr Gray had had to borrow a hockey stick from this foreign club, so that he could have copies made for his Japanese team to use.

The following quotation is taken from the commemoration book published to celebrate the sixtieth anniversary of the Keio University Hockey Club.

> The day, in 1906, when the British Mr W.T. Gray instructed students in Keio University on the game of hockey, is regarded as the official birth of Japanese hockey.

In early 1906 a prospectus was released announcing
the establishment of the Hockey Club of Keio
University, under Kazuichi Ogura, a member of the
teaching staff. In mid-November Mr Gray, a minister
of St Andrews Church, and a former hockey player at
Trinity College Dublin, presented a lecture on hockey
to volunteers at the new college auditorium.

On November 23, at 3pm in the Shiba Park ground,
Mr Gray showed how to play the game of hockey,
with a stick in his hand. A commencement ceremony
followed at the dining hall in the Keio Club. There
were a hundred participants. On November 26, hockey
practice began at the grounds of Hibiya Park.

One student recalls this introduction to the game:

After seeing a notice for the lecture on this sport
called 'hockey,' I went along with my classmates to
listen to Mr Gray explaining the game, translated by our
senior, Mr Ogura. We were so impressed to see how Mr
Gray handled the stick on the ground, we immediately
joined, and continued playing for the six years until we
graduated.

The re-opening of communications with Japan brought
great joy to Mr Gray, but the excitement was if anything greater
from his former students. After several exchanges of letters,
the news came in from the hockey club of the inauguration
of the "Gray Cup." Mr Gray was invited to the first game, to
be held in Japan, and the travel expenses would be paid. Later
in 1964, Mr and Mrs Gray were again invited to Tokyo for
the Olympic Games. Mr Gray looked forward to making the
journey, but eventually this didn't happen, owing to concerns
for his age and health. So instead he delivered a message. Why
did these Japanese students show so much respect? I think it was
because he was a good coach and treated them with passion and
warmth, and above all he was a true gentleman.

When Mr Gray recalled his memories of Japan, he didn't refer to his religious activities at all, but only to hockey, and in a joyous manner. He had been sent to Japan as a minister, and coaching the game started as a hobby. He would joke that he was sorry that hockey was what he was remembered for, and not the missionary work. The people who played under Mr Gray had learned manners and sportsmanship. From letters I gleaned that Mr Gray was very particular in teaching correct English pronunciation. As a Protestant minister, he was wont to give rigorous instruction, for example "Sportsmen are not to drink, or smoke." Some wrote to me, recalling that they weren't allowed to drink on a training day. When the hockey club started its activities, it wasn't officially acknowledged as a sports club. Hence it appeared not to get as much funding as some other clubs. Mr Gray, finding that the students had little money, conducted fundraising for the club, and treated the players to a good dinner on some occasions. He looked after each student. He treated me and my family in the same way and became a father figure to us, who had few other friends at the time.

After we moved to the US in 1965 we continued to exchange letters. One of them sadly informed us that his wife had passed away. As soon as we came back, we visited him at a nursing home; he welcomed us back with the same smile, even though he looked a little older. He had prepared his Bible and an old English-Japanese dictionary from his time in Japan, and handed them over to us, saying, "For you to remember me." In the early winter of 1968, a short while after this visit, he passed away at the age of ninety-three. His grave in Mount Jerome Cemetery in Dublin still sees visitors from Japan to this day.

Alumni of Keio University Hockey Club still refer to the club as the "Gray Club," honouring the achievements of this man, as well, perhaps, as the colour of their hair. A small monument was erected in his memory by his grave. I sometimes wonder

how many other benefactors of sports in Japan receive the same respect.

In the commemoration ceremony to mark the birth of hockey, delegates were invited from the Irish embassy in Japan. One of my students from the old Japanese course, Mr Peter Smith, made a dedication speech in fluent Japanese, which pleased the participants, I imagine.

Chapter 4

Small Family and Big Family in Dublin

OUR LIFE IN THE sixties in Dublin was full of extraordinary events and experiences that were interesting and precious.

In those days before computers and the internet, the only accessible Japanese media were month-old newspapers and magazines sent from Japan via surface mail. Starved of anything to read, I devoured them from start to finish feverishly. There were overseas telephone services available, but they needed to be booked days in advance. Even when a call was connected, the voice quality was far from satisfactory, very often not clear enough to follow, and frequently the call would drop in the middle of a conversation. And then the extremely high charges were another reason why we rarely used the phone. Instead I depended on the postal service to keep in touch with Japan. I struggled to read the local newspapers with a dictionary in one hand. My husband enjoyed *The Guardian*, which had been recommended by his English colleagues. The transistor radio we had brought from Japan was regarded as a curiosity.

Then again, Honda motorcycles were selling well in Dublin following their win in the Isle of Man race in 1961. Honda used Japanese logos embossed on their tyres to identify the brand, and in those days they were the only Japanese characters to be found in the city. We were thrilled whenever we came across them.

There were not that many people who owned cars then. Among my husband's colleagues, few owned a car at that stage. From his workplace in UCD, then housed in government

buildings near the centre of the city, he would drive home to have lunch and then back to work. That is an indication of how little traffic there was back then. My husband pointed out that the journey was so lightly congested that he hardly needed to use the brake. It was common then, throughout Europe, to have lunch as the main meal, and many people would make the round-trip journey between home and work twice a day.

He had bought a used Morris Minor and started driving early on, while still taking lessons from one of his colleagues. At the time all it took to get a driving licence was to hand over the sum of one pound; no test was required. When he mentioned this to two Japanese friends attending an academic conference, both went out and purchased licences as souvenirs.

Not infrequently, a total stranger from Japan would turn up on our doorstep without any notice. As we were a young couple without the ability to say no when people reached out to us, we ended up offering whatever help in our capacity as "unofficial ambassadors." In hindsight, it is a wonder how they even found us back then, before email and the internet. At one time we received a visit from a Japanese chicken sexer, who was staying in Dublin for a short while. He explained that his job was to determine the sex of newly hatched chicks, and he was able to do this at the rate of a few chicks per second. He claimed that the Japanese excelled in this, and quite a few sexers were hopping around the globe. I remember asking myself, what other jobs would allow people to travel around the globe with a single skill?

On the subject of skills, Dublin hosted the "Skill Olympic Games" (officially known as the International Skill Competition) in 1963. Japan was a participant. Upon their arrival, the first thing the Japanese delegation requested at the airport was, "Please find the Ushiodas." The head of the delegation was Mr Kodama. When I heard he was also one of the executives of Hitachi, I recalled my father mentioning that name frequently

when he had worked in Hitachi. I surmised that Mr Kodama had heard about us from my father before leaving Japan.

Whatever the case, while they were en route from the airport to their hotel, my husband, having received the news on the phone, rushed to the hotel and met them as they arrived into the lobby. When he met the head and the senior members of the delegation, they handed over a large can of nori (roasted seaweed).

"Could you make us onigiri (rice balls) with this for our participants each day? Without rice, the competitors wouldn't be able to gain energy."

My husband arrived home with a worried look on his face, and mentioned that they would just need onigiri every day. Having understood, I felt that they needed something extra, a side dish of some sort. I bought a whole salmon, sliced it up and salted the slices. Next morning I grilled the salmon slices in my little kitchen and wrapped each slice in paper, as at the time neither plastic wrap nor aluminium foil was available. I would deliver these lunches each day to the examination hall. Fortunately, there had been such a bumper catch of salmon that year that it was even used for fish and chips, so I was able to get it at a very reasonable price. The fishmonger who helped me then remained a good friend through the decades, and always called me whenever rare or unusual fish had been brought in as part of the catch. In return I've introduced him to newcomers as they arrived from Japan, including a procession of chefs working for the Japanese ambassador in Ireland.

This daily Japanese lunch must have had some effect as Team Japan attained first place in the games with ten gold and two bronze medals. I was so delighted that I forgot the hectic mornings I had spent preparing and cooking rice and fish. To be honest, this was not the only troubling thing about the competition. The Japanese delegation comprised only a dozen or so contestants, but they were accompanied by a number of

bureaucrats and seniors in the companies that the contestants worked in. At the request of these bureaucrats my husband took leave from the college and spent his whole time interpreting and chauffeuring these people around with his car. It was barely ten years after the end of the war, and it seemed that quite a few officers who had left the military had moved to senior management in these companies or had become bureaucrats. During the competition, whenever they had a need for help, they would stand up in a hallway and shout, in Japanese, "Dr Ushioda, I need you to contact me now!" even though my husband would be translating for the contestant in the hall. It must have been off-putting for the contestants from different countries, as they did this loudly and in Japanese. My husband, a young man, was not wont to tell his seniors to calm down, and ended up baffled and stressed by the whole experience.

A Japanese celebration party was held on the last day at the hotel to mark the outstanding achievement of the team. Two diplomats from the Japanese embassy in the Netherlands, who officially covered Ireland back then, travelled over to throw the grand party. We were invited, and received effusive thanks from Mr Kodama, and our children, who had been so good while their parents had been busy, were honoured with gifts as well.

Subsequently, in 1964, a Japanese embassy was established in Ireland, and the counsellor who moved from the Netherlands to Ireland a few years afterward was Mr Kaneko; he had been at this celebration party and had taken a photo of our family back then. We remained close family friends for many years afterward.

Chapter 5

The Beginning of My Days at the Chester Beatty Library

As I've said, in the spring of 1970 I started to work as a volunteer cataloguing the collections of the CBL, at the same time teaching Japanese to the curator, Jan Chapman. Jan told me that we would begin with the ukiyo-e prints, as this had been the strong direction of the board of trustees. There was good reason for this.

Some time earlier there had been a number of thefts targeting Oriental art, especially ukiyo-e, in the UK and parts of Europe. This had received extensive press coverage. Indeed, the Chester Beatty collection had also fallen victim to a few thefts. Among them were Hokusai's famous "Thirty Six Views of Mt Fuji," including the masterpiece "Red Fuji," as well as several other fine pieces. These were part of a package of purchases that Mr J. Hillier, an eminent researcher and art dealer, had made at Sir Chester's request in the 1950s and afterward. In the inventory of purchases that Mr Hillier had left, I noted that the stolen items had been underlined, presumably to indicate that they hadn't been recovered. Anyway, I could see that the art thieves had good expertise when it came to spotting the valuable pieces. This had added a greater sense of urgency to the need to start cataloguing the ukiyo-e collection immediately.

The ukiyo-e prints in the collection were already mounted. To be precise, each print was fixed on a cardboard mount with a tiny piece of adhesive tape at each corner and covered with a sheet of cellophane paper, which was attached to the rear of the

mount and folded over the front to cover the print. Therefore to catalogue the item, that is to determine the title, series, and artist, we had to try and make the details out through the cellophane paper. This was hard enough, but there was another, bigger obstacle. A cursive style of Japanese writing was used in the ukiyo-e prints, and some characters were incomprehensible at first glance to me, even though I had majored in Japanese literature and had had some experience in reading classical calligraphy. Fortunately the library had some English books on ukiyo-e, so using these Jan and I strove to glean the details for each print. Our progress was very slow. When Mr J. Hillier's original inventory purchase list turned up some time later, this proved to be a great help.

While working on what was in effect a decoding project, I had some difficulty in deciphering and interpreting the old-form Japanese text and writing. This is something that ordinary Japanese struggle with. Therefore, I took photos and had them developed into slides. When I studied the enlarged images at home, sometimes I made a breakthrough, at other times the writing remained a mystery to me. While I continued to struggle, I received some reference texts and documents that helped my progress somewhat. Nevertheless, it took a couple of years to complete the first version of the catalogue, covering about 350 surimono prints (these were privately printed and used for greetings and other occasions) and 450 ukiyo-e prints. Finally we had to put a stamp marking the CBL ownership directly on each print—and this was a very nerve-racking job.

Until I had come to work at the CBL, ukiyo-e prints had been unfamiliar territory and I knew very little about them. I had only seen them in the Boston Museum. At the CBL I had to learn everything from scratch by studying the genuine articles and using reference materials. Decades of this hard work has turned me from a complete beginner into an expert (I suppose), and I've been able to produce catalogues, plan exhibitions, and

above all write commentaries and texts on the collection for Japanese art books. I could not have imagined how things turned out. It was a fortunate but very gratifying experience to be able to devote a great deal of time to studying and working with the very best woodblock prints firsthand.

Chapter 6

Sir Chester Beatty and His Collections

ALFRED CHESTER BEATTY WAS born in New York in 1875, the son of an American couple with Irish ancestry on the paternal side. He had an unusual interest in rocks and minerals from his childhood and chose to pursue mineralogy and mine engineering at university, graduating from the Columbia School of Mines in 1898 with excellent grades. He turned down any financial help from his father, a wealthy banker, and headed to Denver, Colorado in June of that year with a one-way ticket and two hundred dollars in his pocket.

This was the Wild West of the late nineteenth century, and an immense worry for his mother. Chester needed to reassure her by carrying a letter of introduction from Mr John C.F. Randolph, a successful mining engineer and friend of his parents. But he soon discovered that this didn't guarantee any sort of well-paid job. With nothing else on offer, he took work as a physical labourer and worked in the gold mines, which paid twenty-five cents per hour, for a ten-hour day of heavy manual labour.

First-hand experience of this kind of rough and often dangerous work taught him the virtue of diligence, which, he would later reminisce, laid the foundation for eventual success. With his academic background in mine engineering, and his hard work ethic, he rapidly advanced his position, from miner to foreman to supervisor then mine manager. Later he would found his own company, Selection Trust, a multinational conglomerate with mining interests around the world. It provided Beatty with immense wealth.

While his career flowered, his health was hampered by silicosis, a serious occupational hazard for miners. His doctor pronounced that he would only have a few years to live, and he was refused life insurance. His life in his late thirties and forties must have been overshadowed by the prospect of this death sentence, so he could hardly have imagined that he would live on until the ripe age of ninety-three, and become a world-renowned entrepreneur and cultural benefactor.

In 1912, at the age of thirty-seven, he quit the mining business and moved to the UK, heeding his doctor's advice to put distance between himself and the mining industry in the US. His friends, colleagues, and partners were dismayed when he left and fervently hoped that he would return. In fact, two years later, in 1914, he did return to the industry, this time as a mining consultant. Based in London, he made steady progress and expanded his business to Russia and Africa when the First World War ended. Helped by the increased demands for raw materials in that era, he came to amass an enormous fortune.

With these funds, he purchased pictures, paintings, art objects, and manuscripts descended from various ancient civilizations. During the war period, while waiting for the chance to grow his business empire, his eyes were opened to the treasures that the great world civilizations and cultures had left behind. He collected Babylonian clay tablets, Egyptian papyrus texts, Turkish and Persian miniature paintings, illuminated Qur'ans, and such like. In a note left by Richard Hayes, the first director of the library and a close friend of Chester in his later years, he remarked that Western collections were completed and already in place. This is the reason that Chester, who only sought top quality, directed his attention to Oriental treasures, as they were relatively unexplored.

Yet it's interesting that his love of Oriental arts had first appeared much earlier, before the Great War, when he frequently visited the Oriental art dealer Yamanaka & Co in New York.

The company had originated in Osaka, and with support from influential figures in the Oriental art world, such as Fenollosa, Bigelow, and Morse, had successfully made inroads abroad into foreign markets. The first branch opened in 1895 in New York; Boston followed four years later. Without question, a large part of the Japanese collections at the Boston and Chicago museums had been procured via this company.

Chester Beatty recalled that when he was ten years old, he accompanied his father to an auction and caused quite a stir when he bid ten cents for a piece of pink calcite. It was his interest in minerals and precious and semi-precious stones and their formations that developed into his appreciation of intricately and finely carved jade *objets d'art* and snuff bottles, which he began collecting seriously from about 1910 onward, or even a little earlier. He had become fascinated by the beauty of such items and kept on collecting a wide range of colourful specimens made of rare materials, in the same way as he might have organized mineral samples. Snuff bottles that he purchased at this time show his love of rare materials, beautiful colours, intricate design, and most especially, the mysterious beauty of jade.

Chester Beatty purchased Japanese arts and crafts from Yamanaka & Co as well, including netsuke, inrō, lacquerware, and some katana sword guards. This too may have marked the proper beginning of his collection of Oriental art objects. Throughout his lifetime of collecting, there would be a consistent feature of rich colours, especially the vivid colours to be found in miniature paintings. For Chester, who had been interested in mineralogy from childhood, colours made from mineral pigments must have been particularly appealing. Perhaps it's no exaggeration to say that he amassed world treasures with the eyes of a mining engineer.

The main body of his Japanese collection had been believed to have been purchased in Europe sometime in the 1950s.

I, however, did find some indications that this did not apply to some of his collection and did some research, which I will return to later. Among the purchases made around this period, there are also unique illustrated scrolls and books, which are typically characteristic of his entire collection. Perhaps I can describe a few examples.

Two sets of scrolls, "Illustrated Scrolls of the Sado Gold Mine" (Sado Kanayama Zu) and "Picture Scrolls of the Metallurgical and Mining Processes of Coins" (Tsūyōgin Oyobi Nibuban Nishuban Fukikata Tetsuzuki Ezu), had interesting histories prior to his owning them. The first foreign owner was Dr W. Gowland, a British metallurgy expert who was invited to Japan by the Meiji government in 1872 for the currency unification process. He worked at the Osaka Mint Bureau for fifteen years, which was an unusually long period for an expatriate. During this time, he conducted archaeological surveys on ancient tombs located in different parts of Japan. A century later, the dry photographic plates he had taken were re-discovered in the British Museum. I remember how excited I was when I found this article in the *Asahi Simbun* newspaper in a hotel room in Tokyo on November 23, 1991. When he left Japan at the end of the currency re-unification, Dr Gowland would probably have received some gifts from the government in recognition of his work, in all probability these two sets of scrolls. After more than a half-century, they found their way into the hands of Sir Chester in 1953 and now number amongst the collection in the library. Even in his later years, Sir Chester was deeply interested in mineralogy and mining, and this interest remained a core feature of his collection.

I'm convinced the detailed illustrations in the three scrolls of the "Sado Gold Mine" must have reminded him of his younger days in the gold mine in Colorado. The mines at Sadogashima Island were under the direct control of Tokugawa Shogun and the selling of maps or illustrations of the mines was

not permitted, so all in all, these scrolls were an unusual and valuable record.

Amongst the collection Sir Chester purchased in his later years in Europe, there are other kinds of scrolls that I would like to describe, and each shows that he was not merely a lover of art. "Illustrated Scroll of the 1837 Famine" (Tenpō Hachinen Kimin Kyūjutsu Zukan) and "Picture Scroll of the Festival of the Good Harvest of 1839" (Tenpō Jūnen Hōnen Odori Zukan) depict a famine, and a bountiful harvest festival with dancing villagers. Another is "Picture Scroll of the Earthquake of 1855" (Ansei Daijishin Saika Zukan), which depicts in painstaking detail views of Edo, now Tokyo, during the great earthquake of October 2, 1855. These scrolls served as precious primary records before the advent of photography, and no further narrative is needed to describe the dreadful circumstances depicted. According to a memo found in the scroll box of the earthquake, it was produced to order by Prince Konoe. Besides these items, there are many objects in Chester Beatty's collection that record Japanese customs, techniques, industries, *inter alia.*

In 1917, Sir Chester embarked on a world cruise to rest and recover from illness. He stopped over in Japan for four months, and he frequented Yamanaka & Co in Osaka, then run by Sadajirō Yamanaka. Through this company, Sir Chester purchased some Japanese art objects during his stay. It's important to note that many years earlier, pioneering connoisseurs of Japanese art such as Fenollosa, Bigelow, and Okakura had made significant purchases from the company's founder, Kichibei Yamanaka. Most of these items had found their way into the Boston Museum. It brings home to me the very integral part that Yamanaka & Co played as a channel for moving treasures from East to West. This would last until the Japanese government legislated for the preservation of important treasures in 1921 and 1923.

In his lifetime, Sir Chester Beatty presented his collection to

Ireland, and he set up a trust to ensure that his collection and library would be maintained intact, properly and professionally curated, and made accessible to scholars and, through exhibitions, to the general public.

Why Ireland? Well, Sir Chester's ancestors did come from Ireland and he did spend his later years there. Another possible factor was that his son already had a summerhouse in County Kildare. But the main reason seems to stem from the Labour Party win in the UK general election of 1945, and its taxation policies. During the Second World War, Chester worked as an adviser to the wartime Conservative prime minister, Winston Churchill. He helped in the supply of much-needed minerals and also helped the Red Cross by opening up his mansion, Baroda House, as a hospital for them, while he moved into an apartment, where he continued to live after the war ended. These contributions were recognized and rewarded with a knighthood. This close collaboration between him and the British government didn't last long when the Labour Party entered government. Chester became increasingly unhappy with the increased levels of bureaucratic red tape and foreign exchange restrictions in post-war Britain. However, the high taxation rates that were introduced by the Labour government seem to have been ultimately what persuaded him to move to Ireland, where he established the Chester Beatty Library to house his Oriental collection. As mentioned earlier, he had presented the Western paintings, collected for his wife, to the National Gallery of Ireland. However, one painting from that collection, *Sunflower* by Vincent van Gogh, which had long been admired by Beatty and his wife in the great hall of his mansion, ironically came into the possession of a Japanese individual in 1987.

According to a friend of mine, then a curator of the Oriental art section of the British Museum, all of Chester Beatty's collections had been expected to be donated to the British Museum and exhibited in the "Chester Beatty Collection" room. As he regretted to me when we had the opportunity to

work together in Japan, "The one that got away is always the biggest fish."

Sir Chester's London residence, Baroda House, was famed for the social gatherings he and his wife hosted. It happened to be near the Japanese ambassador's residence in London. This was something that Ambassador Yamazaki pointed out to me during a visit to the CBL some thirty years ago when he noticed the address on Sir Chester's letters. He added that it had subsequently become the residence of the ambassador of Saudi Arabia.

Following his relocation to Dublin in 1950 Sir Chester spent more relaxing days after retiring from frontline work, and only visited London thereafter. During this period, through his European friends, he purchased many art objects of quality, including Japanese prints. He regularly invited friends to his library in Dublin, where he arranged viewings of his collection as well as workshop-type occasions. Among the purchases from this period, I would like to highlight the ukiyo-e collection of Dr M. Cooper, the most famous collection of its kind at that time. Sir Chester bought this collection in 1954 on the recommendation of his close friend, Mr Wilfred Merton. Despite its extremely high price, he went ahead with the purchase as the quality was superlative. His guiding principle was always to value expertise and to stress that he wanted "Quality! Quality! Always Quality!" Among his later purchases I want to mention also the surimono prints. Sir Chester collected this genre even when the market didn't place much significance on them. He especially valued their scarcity, as these were "private prints." This collection is now world-renowned and has been exhibited in many parts of the world, thanks to Sir Chester's foresight about what was worth collecting. His entire collection, including the surimono prints, is now preserved and cared for at the newly built Chester Beatty Library located in the extensive premises of Dublin Castle.

Chapter 7

Heavenly

TARA IS THE NAME OF the Georgia plantation central to *Gone with the Wind*, Margaret Mitchell's best-selling novel. In the novel it's named by an Irish immigrant after the Irish Hill of Tara, which is in County Meath, not far from Dublin. In the mid-nineteenth century, Ireland was ravaged by the Great Famine, which was caused by circumstances where, through poverty, nearly half of the population were forced to depend on the potato as the sole source of food, and a severe potato blight destroyed the crops for several years. The Great Famine resulted in an unprecedented number of people dying of starvation and related illnesses. Since then the Irish have travelled widely and emigrated periodically. It's now believed that over seventy million people worldwide call themselves, in some way, Irish. The population of Ireland itself is four million, even today below what it was before the Famine. John F. Kennedy was the first Catholic Irish descendant to be elected US president; the joy and pride of the people in Ireland at the time was indescribable. On his visit to Ireland, enormous welcoming crowds met Kennedy everywhere in Dublin and at the ancestral home in Wexford that his great-grandfather left during the Famine. The visit was in June 1963, just a few short months before the tragedy of his assassination.

Other US presidents, including Nixon, Reagan, and Clinton have made state visits to Ireland to honour their Irish heritage. In May 2011, Barack Obama travelled to Ireland, visiting Dublin and a small village, Moneygall, in County Offaly, his ancestral home on his mother's side. Together with his wife,

Michelle, they shook every hand in the crowd, and enjoyed the perfect pint of Guinness in the local pub. The joy of the nation was dubbed Obama Fever. In a speech in Dublin, just before his departure, the president, speaking about the contribution of the Irish in America said, "Never has a nation so small inspired so much in another."

All these stories move me, now that I've lived in Ireland for over half a century. I've imagined that for most of the people living in the rest of the world, Ireland is just a small country situated on the western edge of Europe. Some have even believed it was a place of fairies. I too knew so little about this country at first, just that it was a small island where people spoke English, and perhaps it was a part of the United Kingdom?

After my husband left for Ireland in 1959, I moved back in with my parents, and we enjoyed being reunited, with Kazuaki at the centre of our attention. One night in autumn we were watching a quiz programme called "My Secret" on the national broadcasting channel NHK. One of the guests caught my attention.

He explained that he was a Japanese-born American diplomat heading to Ireland, where he would be working at the US embassy.

Since Ireland was of foremost interest to me, I wondered why this Japanese person was working in the US Embassy in Ireland. I can't remember the exact words, but he mentioned something to the effect that there were quite a few Americans living in Ireland, so his duty as a consul would be of great importance. He added that he was distantly related to Ms. Aki Fujiwara, one of the regular panellists on the programme. Another question that puzzled me was why there were so many Americans living on what I thought was a very small island. Furthermore, his clear, well-spoken Edo (Tokyo) accent had me wondering how he might be American.

During the programme, he revealed that he was a Japanese

native from a respectable family of former nobility, born in Tokyo in 1913, and had taken English lessons from a very young age. While he was in college, his enthusiasm for the then-popular Hawaiian music went overboard, so much so that his parents cut him off. Since he was fluent in English, he moved to the US and made a living doing translating work while teaching Japanese from time to time. He soon married an American girl and stayed in the US during the war period. Not that this passed without incident; he spent a brief period of internment in a relocation centre. He was released after a short period on the grounds that he and his wife already had a child and was henceforth treated as a full US citizen.

Some months after I watched the programme, I landed in Ireland. A few years later I had occasion to meet this person. It was the very first reception that the Japanese embassy held to commemorate the Emperor's birthday in 1964. When I mentioned the television programme, he exclaimed happily "Oh my God!"; it didn't take long before we became close family friends with Mr Kiyonao Okami. He had missed Japanese food very much, and he enjoyed my cooking with the Japanese vegetables we grew in our garden. One summer day, when we went to the beach together for a picnic, we shared a bento lunch with his daughter, Marisa, who loved the rice balls (onigiri) that I had made.

As a consul, Mr Okami helped American residents with various difficulties, large and small, such as pension claims. He met with visitors from the US, who outnumbered visitors from any other country to Ireland. While his schedule was always full, it reached a peak when President John F. Kennedy paid a state visit to Ireland in 1963. There was an overwhelming welcome for the president from all corners of the country, including Dublin, and of course Wexford, where his ancestors had lived before leaving Ireland. Mr Okami had a hectically busy time during the preparations and the actual visit.

A few years later Mr Okami retired and became involved in establishing the local branch of the Marubeni Trading Company. Around this time, the Japanese Economic Mission approached my husband to set up its counterpart in Ireland. Mr Okami was one of the friends my husband asked to help out in setting up the organization.

There was another person, also from the US, but with a different background, that we were very friendly with.

Amongst the many policies that the former Taoiseach (Prime Minister), Charles Haughey, introduced was the Artists Tax Exemption Scheme in 1969. This was unique, and succeeded in attracting a number of artists including writers, painters, and musicians from all over the world to Ireland.

One of these was Mr Robert Elegant, an American writer and novelist. During the early post-war years he worked actively in China and Japan as a correspondent for the *Los Angeles Times* and *Newsweek*. In Hong Kong he met his future wife, then a Pan Am stewardess. He later wrote a novel, *Dynasty*, depicting a turbulent China from the period of the Boxer Rebellion up to the Cultural Revolution. This epic saga became a bestseller. He and his wife moved to Ireland and kept an Oriental lifestyle in their Wicklow mansion. It was filled with Chinoiserie furniture and carpets, and the whole mansion—apart from the pool—had an Oriental appearance. The couple visited the CBL frequently, and I got to know them quickly.

Robert Elegant and his wife Moira were delighted to make acquaintance with Japanese people in Ireland. They would often invite us to parties at their mansion and introduce us to some of their artistic social circle. In no time at all, we became close friends with the Elegants. One day I received a phone call from the fishmonger in our neighbourhood to tell me that fresh tuna had just come in. I immediately rang Robert and Moira.

"Really?! Incredible!! Is it the same kind of tuna that we

adored in Tokyo?" Robert could scarcely hide his excitement and asked, "Can we come over tonight?" They must have headed out the door and over to our place in their red Mercedes sports car almost immediately, hardly waiting for my reply, which was "Of course!" They appeared on our doorstep in a very short time.

"Toro no nigiri!" (sushi with the choicest fatty tuna) he exclaimed in Japanese as I put the platter on the table. Over dinner he repeatedly murmured "Heavenly!" as he savoured the really exceptional tuna. "When was the last time I had such excellent sushi?"

Moira, his wife, enjoyed the delicacy just as much. I was so pleased at their joy in tasting something that they had obviously been missing that I prepared some more sushi, this time with some of the leaner tuna, for them to be able to take home.

So whenever I come across the word "heavenly," I'm reminded of that wonderful sushi dinner we had with the Elegants. It was an unforgettable night that brought me a lot of joy, truly a heavenly night.

The excellent tuna fished in Irish waters or landed in Irish ports gave rise to many other interesting episodes too. I would like to mention one that involved Professor Takashi Oshio, a researcher in German literature and a dear friend for over fifty years. He was a real food lover. While working in Cologne as head of the Japanisches Kulturinstitut he suffered an illness brought on from overwork, and had to spend some time in the hospital. Fortunately it wasn't a serious matter, and he demanded to be discharged early, as he could not eat the food served at the hospital. One day, the Japanese ambassador in Bonn visited him in the hospital and explained that he didn't bring any flowers, as he was quite afraid that Professor Oshio would eat them!

About forty years ago, Professor Oshio would complain

about the quality of fish in Germany. Whenever he visited us in Dublin, I would prepare grilled salmon and rice balls (onigiri) for him to take home. He would enjoy these on picnics with his family in the nearby German countryside, perhaps beside an old castle.

Some years later, as tuna became more available in Ireland, I had the good fortune to buy a few kilograms of excellent quality. I was so excited that I mentioned it in my next letter to Professor Oshio. Some days later instead of sending a reply letter, he turned up in person on our doorstep. Of course, needless to say, we had a tuna party that night. One other person, Dr Sanada, who was studying at UCD, joined us. The nigiri sushi that we enjoyed that night was truly heavenly. While at college in Japan, Dr Sanada used to live with a family that ran a sushi restaurant, and had learned to make sushi there. He was a near professional, and the thick-rolled egg omelette toppings that he made were a favourite. To make the whole thing more authentic, we hung a Japanese tavern curtain at the door, thus turning our dining room into a true "izakaya." Professor Oshio loved the heavenly seafood; he, who was usually so talkative, scarcely said a word once he started to eat.

Chapter 8

Presenting Nara Ehon to the World

WHILE THE CATALOGUING OF the Chester Beatty collection was underway, I received an unexpected visitor from Japan. He was not an expert on ukiyo-e or a collector; he was a researcher of Japanese medieval literature, Professor Gensei Tokue from Kokugakuin University. He explained that he had come to Ireland to see Nara ehon. I had never heard of this genre before, so I wondered if I could find this material even if it were hidden somewhere in the library. I still remember that morning when I greeted him a little anxiously in the dimly lit library. It was the spring of 1974, and Jan Chapman and I had started working on other areas, having finally finished cataloguing the woodblock prints. I had started on the colourful illustrated books and scrolls as they interested me; the works included Japanese classics, *The Tale of Ise* (Ise Monogatari) and *The Tale of Genji* (Genji Monogatari), that were familiar stories. But the Nara ehon genre was completely unknown to me.

Professor Tokue was interested in viewing a set of three scrolls called "Illustrated Scroll of the History of Musashibō Benkei" (Musashibō E Engi). After a short search I found them in a black lacquer box in a cabinet in a dark room. This was the first time I had seen Nara ehon and I respectfully presented them to him, still wondering how they had got their name.

The professor carefully unrolled the scroll with his white-gloved hands, a half-metre at a time, on a table covered with green baize that he had brought from Japan. As he unwound each scroll slowly it revealed a sequence of text followed by a

picture. He read the legend quietly, and then explained the picture that followed, for every set in the scroll. This was a great opportunity for me, as I didn't even know the proper way to handle scrolls back then. Over the next few days I tried to absorb completely all his detailed explanations and information about the scrolls, taking copious notes.

Although at that time my role was simply that of volunteer assistant to the curator, I was able to help Professor Tokue by translating, since he had difficulty with English. In return he provided me with a private lecture on Nara ehon, which was far more interesting and informative than any lecture I had taken in college.

"The History of Musashibō Benkei" scrolls were produced during the Muromachi period, and this is regarded as rather early in the genre of Nara ehon. Nara ehon generally refers to manual copies of colourful pictures and writing in the form of scrolls or booklets. Not being printed, each copy of the scrolls was painted and written individually, so show differences between copies. They used to be regarded as rather simple and rustic in nature, but there are more elaborate and artistic versions as well. This particular one, "The History of Musashibō Benkei," is regarded as a masterpiece of the genre. The scrolls depict the story of two main characters, Musashibō Benkei and Minamoto no Yoshitsune. Benkei was a warrior monk and is an adored national hero in medieval Japanese literature and performing arts. There are many works based on his life story and folklore. Yoshitsune was a famed warrior. The story begins with the abnormal birth of Benkei, after spending three years in his mother's womb. When he was born, he had the appearance of a demon-child (oniko) and was abandoned on a mountain, but was later rescued by Gojo, an Imperial court counsellor (dainagon). He was sent to train at a Buddhist Temple at Mt. Hieizan, where eventually his aggressive behaviour drove him out. His continuing violent exploits finally came to an end

when the warlord Yoshitsune defeated him and he exchanged vows to serve as vassal to Yoshitsune.

According to the professor, a complete set of "The History of Musashibō Benkei" had not been found anywhere outside of the Chester Beatty Library, which made this example unique.

You might wonder what had brought Professor Tokue to this small library, which had been open but not well-known, in distant Ireland. How had he known that such a rare item would be found here?

The unlikely answer begins in a tiny restaurant in Kyoto where a Columbia graduate student, Barbara Ruch, now Professor Emeritus at Columbia University, was having lunch. In those days one rarely encountered westerners in Kyoto during the winter months. By coincidence another foreigner came into the same tiny restaurant and ordered lunch too. They could hardly ignore each other's presence and began to make conversation. He was an Englishman, specializing in Chinese painting and Japanese woodblock prints. After Barbara mentioned that she was working on medieval Japanese illustrated narratives and described this kind of artefact to him, he replied, "If you're ever in Dublin, Ireland, I'm sure I once saw some manuscripts like that in a small library there." Slightly astonished, this advice stayed in her mind as she continued her research in Kyoto. Six months later when her work in Japan was finished, she headed to Ireland on her way back to New York.

Arriving in Dublin, she could not figure out immediately what or where this library might be. Having made enquiries with quite a few people, she eventually found herself outside a small, red brick building. The only person in sight was an old lady, who was minding the library. Ms Ruch hesitantly explained the reason for her visit, and the old lady replied that she was free to come inside and see what she might find inside the various closets. She stepped in timidly and opened some of the dust-covered cardboard boxes. What she found inside were

magnificent Japanese medieval scrolls, volume after volume of beautifully hand-painted books. She was utterly speechless and overjoyed. This was in 1966, when Sir Chester was still alive and had not yet donated his collections to the nation of Ireland.

This story of the unlikely rediscovery of Nara ehon in Dublin is related in the Sorimachi Catalogue (Japanese Illustrated Books and Manuscripts of the Chester Beatty Library, Dublin, Ireland) in the preface entitled "The Age of Miracles." Barbara Ruch spent the next few years publicizing and broadcasting these finds in Dublin to various researchers throughout the world. She especially wanted to show these precious treasures to Japanese scholars and researchers, so she started to make plans for the first international conference on Nara ehon.

While she completed her doctoral thesis on Nara ehon, she set about researching the collections at the Chester Beatty Library. As this library wasn't well known to the public, she probably received collaboration from some people privately hired by Chester Beatty himself to complete a simple list of the Japanese medieval picture books and scrolls. It was based on this information that Professor Tokue came to visit the precious collection hidden in Dublin.

In 1978, four years after the Japanese researcher's visit, the first International Research Conference on Illustrated Japanese Literary Texts was held at the Chester Beatty Library. This was the first step to put this little library on the world map. Over thirty participants, some accompanied by a spouse, arrived in Dublin from Japan, the US, the UK, and France, to attend what became a successful meeting. Among the participants was Professor J.M. Rosenfield, from Harvard, whom I had met during my time in Boston; and it was a happy reunion.

In order to realize the conference, Barbara Ruch had to work extraordinarily hard to disseminate information, network researchers, and secure funding from various foundations. For Jan Chapman and myself, it was a very hectic time as well

making preparations. We were in contact with Barbara, getting the conference organized and dealing with lots of questions from participants, and this required a lot of translation between Japanese and English. As many of the Japanese had never travelled abroad, lots of difficulties arose, and I had to spend a good deal of time to resolve these.

It was the first time the Chester Beatty Library had hosted an international conference of this size, so it took a few months for Jan and myself to get the library ready for the occasion. The plan was to divide the participants into several different groups or sectional meetings for discussions on themes of interest to the group as the actual Nara ehon were presented to them. It was therefore necessary to prepare small meeting rooms, each with a bookcase and a display case. This furniture needed to be moved from where they currently resided, so we had to press-gang the security guards to help us. At the same time, we needed to prepare conference schedules and the group meeting agenda details. For this, Jan Chapman prepared and typed up the English documents. But a Japanese version would not be so easy. This was a time before the PC, and complex Japanese typing machines were not available in Ireland. While I was resigning myself to handwriting the material, an idea occurred to me. One of the Ireland Japan Association members who had a very good command of Japanese, Father Drohan, unusually had a Japanese word processor. He had stayed in Japan for a long time as a missionary, and had purchased a word processor during this period. He often mentioned how much he loved this machine. He gracefully accepted my request without a moment's hesitation. This was not the only time that Father Drohan rescued me from some difficulty or other. Some years after the conference, he moved to the Salesian Society in Kagoshima and fulfilled his hope to spend his retirement in Japan. We continued to exchange emails until he passed away aged ninety-five.

As the conference approached, a stream of participants

started to arrive in Dublin from around the world, four from the UK, two from France, six from the US, and thirteen from Japan.

Some of the Japanese participants suffered greatly from jet lag, not helped by their age, and this was a great worry to us. All of the participants from Japan stayed in Dublin's premier hotel, The Shelbourne. We arranged for a bus to ferry them to and from the Chester Beatty each day. In the evenings there were receptions held at the Japanese and US ambassadors' residences, and all the participants were invited and received a warm welcome.

Some years afterward I had occasion to reminisce about some of these memories with Professor Tsugio Miya of the Jissen Women's University. He fondly referred to the gorgeous welcoming reception held by the Minister for Education at Iveagh House on the first night and remarked that something like that would never happen in a thousand years in Japan.

The conference took place for a week in August 1978. During this time, there were sectional meetings on the topics of literature, arts, religion, and bibliography. Additionally there were general presentations by Dr Barbara Ruch as well as British and Japanese speakers. Professor Gardner spoke about the Nara ehon collection in the British Library while Professor Tokue discussed "The History of Musashibō Benkei" that he had studied. Professor Tatsurō Akai described how the Nara ehon had made its first appearance in the late Muromachi period, and was initially intended for commoners with its style of warm, rustic, primitive beauty. This made a strong impression on me.

During the general meeting, a lively question-and-answer session took place. One topic it explored was the interesting question as to whether this new genre should properly be called Nara ehon. The session was concluded by Mr Shigeo Sorimachi, who remarked, "It is indeed a pleasant surprise to find so many Nara ehon at this library in Ireland. Please, Mrs Ushioda, would you investigate when and how Sir Chester developed

this collection? You see, I am familiar with most of the old book markets, but I don't remember ever seeing these before. They must have been on the market well before I started. Please investigate when and where he purchased these!" Thus he ended his speech with a big task for me.

The serious part of the conference concluded at around five each day. The participants took a little break back at the hotel and went out for a pub-crawl in the Dublin summer evening, when it would still be bright until about eleven. They were excited to try genuine Guinness in its hometown. One evening, Professor Masao Okami from Kansai University said to me, "Thank you, Mrs Ushioda, for having picked a hotel with a nightingale floor." I didn't understand what he meant, so another researcher explained that the corridor floorboards on the first and second floors squeaked, or chirped, when walked on. While I imagined that the creaking floorboards just reflected the history of this grand old hotel, I realized then that Professor Okami's remark was a reference to the so-called "nightingale floor" at the Chionin Temple in Kyoto, cleverly designed to warn its occupants against intruders.

There was a free day on Sunday, so we arranged a special social programme for the Japanese participants. We enlisted the help of Japanese families living locally, who kindly volunteered to host the delegates by serving Japanese food and taking them on sightseeing tours to the outskirts of Dublin. This was very popular among the participants.

The First International Research Conference on Illustrated Japanese Literary Texts provided the Chester Beatty Library with a big opportunity to attract global scholarly attention for its Japanese collection. This landmark event benefited the library as well as those researchers who gathered together for the first time outside Japan to study Japanese works of Nara ehon. Furthermore it set a precedent for interdisciplinary meetings bringing together researchers with differing interests

in literature, art, history, and so on. After this conference, subsequent meetings were held in New York, Tokyo, and Kyoto the following year.

The successful conference in Dublin concluded with a delightful farewell reception; it became legendary among the participants present. Our solicitor, Mr Frank Sweeney, and his wife, who were close family friends, invited all the participants to his mansion in Killiney Hill. This magnificent house commanded an uninterrupted view of the Irish Sea. Among the invitees were all the conference participants, all the Japanese host families, together with the staff of the Chester Beatty Library, including Dr and Mrs Patrick Henchy, Jan Chapman and her partner, and others. In total there must have been over a hundred guests. The hospitality was wonderful, and there was delicious food as well as abundant good wine. Sushi and tempura were prepared by wives of Japanese company executives based in Ireland. The conference participants washed away the fatigue of the week with generous helpings of champagne as they endeavoured to communicate in English with other guests and to express their gratitude to Mrs Sweeney and her daughters. It was a wonderful summer night.

Following a suggestion from Professor Akihiro Satake from Kyoto University, everyone stood in a circle, arm in arm, and sang "Auld Lang Syne." The scholars who seemed so authoritative and unapproachable in daylight sang loudly with tears in their eyes. Professor Gardner, a trained college chorister, sang a rich bass line. Maybe it was a result of the hard work that we had put in to prepare and run the conference, but this scene remains a very treasured memory.

Chapter 9

Nara Ehon Conference in Tokyo and Kyoto

IN 1979, JUST ONE year after the very first conference in the Chester Beatty Library, the second meeting on Nara ehon was held in Tokyo and Kyoto with nearly the same set of participants.

The Sorimachi Catalogue that I mentioned earlier had been published just in time for this second conference; it contained Professor Barbara Ruch's preface "The Age of Miracles." Mr Shigeo Sorimachi was someone who had a very broad knowledge of art, books, as well as culture, and added a different expertise as an antiquarian bookdealer and owner of a specialist bookshop called Kōbunsō. In the early spring of 1979, as his eightieth birthday approached, Mr Sorimachi came back to the Chester Beatty Library. This time he brought his wife and Mr Masaji Yagi, his assistant and photographer. During their two-week stay in Dublin, he wasted no time and devoted himself to scrutinizing the Japanese Collection. I had the opportunity to watch them work, helping whenever needed. This intensive examination and recording led to the very first catalogue of the Japanese collection, the so-called Sorimachi Catalogue with the much longer official title "Japanese Illustrated Books and Manuscripts of the Chester Beatty Library, Dublin, Ireland." During the conference in Japan, the lavishly illustrated catalogue was distributed free to the participants. The catalogue was produced at Mr Sorimachi's own expense, and was a great boon to the Chester Beatty Library as well as any researchers. It helped the library's collection become better known throughout the world of Japanese antiquities. Some years previously, Mr

Sorimachi had undertaken a similar catalogue for the Spencer Collection at the New York Public Library. He was remarkably benevolent; in addition to providing the necessary funding, he devoted his considerable insight and editing skill throughout to produce a marvellous volume.

To produce the catalogue, Mr Sorimachi took responsibility for the Japanese narrative; the translation into English was my job. By what magic was it going to be possible to complete the work before the autumn conference? In hindsight, I think it was indeed a period of miracles. When he returned to Japan, we communicated with each other by post. As soon as one segment of his script arrived, I translated it into English and posted it back to him. By this time the next segment had arrived and the process repeated itself. It was so primitive and slow in those days before the internet and email. To make matters worse, the Irish postal service workers went on strike for some weeks during this period. Since I could not think of any other way of getting around this, there were times I had to stand at the Ferry Terminal in Dun Laoghaire harbour with a copy of my translation in hand, asking for some kind person to carry it and put it in a post box in Holyhead in Wales. Despite all of this, we completed the work in time.

From August 20 to 26, the second research conference took place, partly in Tokyo and partly in Kyoto. In addition to the original participants from the Dublin meeting, we were joined by some new delegates from the US.

The conference-opening venue was the National Institute of Japanese Literature, and its head, Professor Teiji Ichiko, delivered the opening speech. The participants then viewed all the Nara ehon that had been exhibited at the institute. Following this, the group divided up into the various sectional meetings as we had done in Dublin. Since most of the participants were on familiar terms with each other, everything proceeded smoothly in a very cordial atmosphere.

The Director of the Chester Beatty Library, Dr Patrick Henchy, and his wife attended the conference as well as myself. To tie in with the conference, two exhibitions of Nara ehon were held, one at the Suntory Museum in Tokyo, the other at Gallery Shibunkaku in Kyoto. There were exhibits sent from the Burke collection, the Fogg Museum, and Spencer Collection in the US, the British Museum and the British Library as well as the Chester Beatty Library in Ireland. They formed a truly spectacular display and pretty much covered the Nara ehon that existed. To transport the exhibits from the Chester Beatty Library, the board of trustees came up with specific instructions. They required that all the exhibits be put into two wooden boxes and travel within the aircraft passenger cabin. They saddled me with the responsibility of carrying this out. I was nervous leaving Ireland with these large boxes, but slightly relieved when Professor Gardner of the British Library joined me in London. Still, it was exhausting for me to travel with such priceless treasures by my side in the cabin.

Then, when we arrived in Japan, I was appalled at the very strict customs inspection procedure. The Nara ehon exhibits included a beautiful box of *The Tale of Genji* comprising fifty-four delicate booklets. I had to open and present these individually for the customs officials, hoping not to damage them in the process. It still gives me the shivers when I think of it.

On the opening day, Professor Barbara Ruch was interviewed on an NHK morning TV show, and she introduced Nara ehon and talked about the conference. That afternoon a public lecture was held, which afforded a good opportunity for the public in Japan to learn about Nara ehon. The following day, Professor Gensei Tokue arranged for all participants to experience a Japanese tea ceremony at an authentic teahouse; this was especially popular among the non-Japanese.

A few days later, the whole conference moved venue to

Kyoto, where the professors from Kyoto and Osaka planned the extracurricular programme. This included visits to Japanese gardens and traditional confectionery shops. In the evenings, after the work of the day, it was party-time. One was held in a terrace restaurant along the Kamo River, and another at a beer garden on a hotel rooftop. The cool breeze was delightful after a steamy day in the centre of Kyoto. Later in the night, Professor Akihiro Satake and Masao Okami from Kyoto University took us to their favourite bar, where we sang "Auld Lang Syne," following the tradition established in Dublin. We received such gracious hospitality, which struck deeply in my heart.

On the last day of the conference, the discussion resurfaced on the validity of the term Nara ehon to cover the illustrated narratives in booklet and scroll forms that were made between the late Muromachi period and the early Edo era. Unlike ukiyo-e from the late Edo period these were not printed but painstakingly hand-written and painted copies. Some supported the use of the term, while others suggested differing terms such as "Medieval / early modern illustrated books" and such like. No conclusion was reached and any decision was postponed to the subsequent conference. Forty years later, the term Nara ehon is still being used.

According to Professor Tōru Ishikawa from Keio University, a leading authority in the field, only recently were the origins of the genre beginning to be understood. Of course, some had simply assumed that Nara ehon were so called because they were produced in Nara in the Kansai region. According to his recent studies, the term Nara ehon seems to have been in use since the Meiji era. Due to the resemblance with Nara-e, which were pictures produced in Nara and used as souvenirs, he presumes they came to be called Nara ehon.

While I was investigating the origin of the term, Professor Tatsurō Akai from Nara University of Education told me there was an Ebashi bridge as well as an Ebashi town in Nara where

the prefix "e" refers to picture or painting, as in "e-hon" or picture book. He said it probably referred to the district where craftsmen who specialised in painting fans were based. That might be the origin of the term. Whatever it is, I hope that future study will find the answer.

Chapter 10

Days and Nights in Kyoto

DURING THAT SUMMER OF 1979, I was busy but happy in Kyoto, taking part in the second half of the Nara Ehon Conference as well as looking after the exhibition in Kyoto. Various activities had been planned in the old imperial city of Kyoto for the after-hours periods of the conference. This pleased the overseas participants in particular. One of these activities was a visit to a long-established Kyoto confectionery shop. Professor Tatsurō Akai, who was an expert in this area, guided the tour. We enjoyed Japanese tea and some of the sweets while listening to his talk on the history and process of manufacturing this traditional confectionery. I still have a wooden mould that I bought during the visit; it hangs in my room and reminds me of the refined elegance of that day.

One night Mr and Mrs Shigeo Sorimachi invited Dr and Mrs Patrick Henchy as well as Professor Ken Gardner of the British Library to a traditional Japanese inn serving the best Kyoto cuisine. I went along as an interpreter. The magnificent traditional Kyoto house and the fabulous imperial cuisine was so impressive that I put at the back of my mind the general tiredness and slight stress of being the interpreter. As I looked at the exquisitely arranged sashimi slices of fish and shellfish, I suddenly remembered that Mrs Henchy was allergic to shellfish. I quickly removed the shellfish from the plate, and the waitress, understanding the situation, filled the space elegantly with some fish. Mrs Henchy was relieved and thanked her. The following dish was "ikezukuri," a Japanese delicacy that I had

never seen before and only heard of. It was a large whole sea bream with sashimi slices of its flesh cut out and then put back in place. It was so quickly prepared by an expert chef that the fish still quivered on the plate. The waitress explained that this luxury dish was not often prepared, since it required a really superb specimen of fish as well as a supremely skilled chef. As I translated into English, Professor Gardner stood up, quite disturbed, and exclaimed in Japanese that this delicacy was just too cruel for him. He was a frequent visitor to Japan and met with and respected Mr Sorimachi greatly for the advice and guidance he provided. But at the same time he was very English and could not condone cruelty to animals. Perhaps it shows that differences between cultures exist, even though there are some Japanese who cannot touch ikezukuri either. In any case Mr Sorimachi quickly had the dish removed and replaced with another, and apologized politely in English. I felt relieved, but Dr Henchy, a keen fly-fisherman, whispered to me that he had heard of the dish and wished that he could have tasted it. Indeed he continued to mention this over the next day or so. The incident cast something of a chill over the evening, making it unforgettable if not memorable.

Just a few days later, before breakfast, I had the TV on in the hotel bedroom. The main news item was the death of a giant panda called Lang Lang in Tokyo's Ueno Zoo. The programme interviewed many sorrowful members of the public, intercutting with pictures of the panda. Presented as almost a lesser news item was a report on the assassination of Lord Mountbatten in County Sligo, carried out by the IRA some days earlier. He had been holidaying there. We too had holidayed often in Sligo, which was the county of the great poet W.B. Yeats. I felt saddened, alone in my bedroom in Kyoto.

When I went down to breakfast, I found Professor Gardner and Dr and Mrs Henchy very quiet, perhaps in shock. Or was the atmosphere strained? One of the American participants

arrived at the table and brought up the news as soon as he sat down. It didn't take long before Professor Gardner became irritated, and the conversation became an argument. I left the table, explaining that I had some urgent things I needed to attend to. When I returned later to the lobby and saw Dr and Mrs Henchy alone, I was rather relieved that this incident too had blown over.

Chapter 11

Wallet Returned

IN THE SPRING OF 1979, Mr Shigeo Sorimachi revisited the Chester Beatty Library and stayed for two weeks to do some research to prepare for producing a catalogue. He brought with him an assistant cum photographer, Mr Masaji Yagi.

One Sunday afternoon, Mr Yagi, having finished up his work for the week, went for a drive on his own in the Dublin Mountains. The weather was very variable, with some sunny spells. True to the saying that you can experience four seasons within a day in Ireland, a rainbow suddenly appeared arching across the sky. Fascinated at the sight, he hastily pulled the car over to the side of the road and started to take photos.

On the following Monday morning when I arrived for work at the library, I was told that there was someone on the phone asking for me. I should say that in those days my office didn't have a telephone, so I rushed out to the main office where the phone was. It was a consul from the Japanese embassy.

"By any chance, is there a Mr Masaji Yagi visiting the Chester Beatty Library?"

The tone was somewhat grave. So I started to reply that there was . . . Without waiting for me to finish my answer, he demanded that I put him on the phone.

I was taken aback slightly, as I knew the consul, and his tone was very out of place. As I returned to the office, I whispered in Mr Yagi's ear that he was wanted on the phone, trying to make sure that Mr Sorimachi was not disturbed. Mr Yagi was slightly startled and then excused himself as he left the room. A few

minutes later he came back and resumed work, explaining just that it was something about his driving licence. As he looked calm and normal, I didn't think anything about it.

During the lunch break, he asked me for directions to the embassy, saying that he had a little business to do there. I gave him directions. It wasn't far. On his way out, he said, "To tell the truth, they found the wallet I lost yesterday, so I'm going to pick it up. Mrs Ushioda, please never ever say anything of this to Mr Sorimachi."

Mr Yagi returned later that afternoon, and kept on taking photos as if nothing had happened. I was very impressed with his respect for his teacher, Mr Sorimachi, who was of a very different time, the Meiji era, and famous for his stern manner.

Later that evening, Mr Yagi called to our home, and explained the mishap in more detail.

It seems that the wallet fell out of his pocket when he climbed out of the car to take the photographs of the rainbow. Some time later, the driver of a truck passed by, saw the wallet, stopped, and picked it up. Checking the contents, he guessed from the business cards inside that the owner was Japanese; he then travelled to the embassy and left it there. The consul who received the wallet saw the nature of the business cards and made the educated guess that it might belong to someone visiting the library. The embassy arranged for the truck driver to be present when the wallet was handed over to Mr Yagi. Mr Yagi was embarrassed, as he was too deeply moved to thank the man properly in words, even though he was obviously very grateful. He expressed his heartfelt thanks by providing the driver with a generous reward.

Mr Yagi acted as buyer for Mr Sorimachi on his various travels abroad, for purchases of antiquarian books for the bookstore back in Japan. This explains why the amount of money in the wallet was very substantial.

The episode was reported in a small article in an evening

newspaper. Although the paper did not record the amount of the reward, it was quite a considerable sum, as the consul related to me afterward. Mr Yagi kept the article as a memento of the event. Thirty years on, whenever he recalls the trip, he never fails to mention how grateful he was for the honesty and kindness of the Irish truck driver. Mr Yagi now runs a bookstore dealing in antiquarian books on the history of the countries of the West and their interaction with Japan.

Some of you might think that this anecdote might only have taken place in those earlier times, when Ireland was still an idyllic place. The following incident happened some twenty years later.

I was teaching Japanese art history in Trinity College Dublin, and after one lecture I met up with an old friend who was revisiting Dublin, together with her husband, after a long absence. We enjoyed catching up over tea at a small café on Grafton Street. The friend used to study Yeats at University College Dublin and moved to the US after obtaining a teaching position there. This was the first time I met her Canadian husband, a nice gentleman who sat patiently listening to us chatting away in Japanese.

I was so fully caught up talking to her that it took some time before I realized that my bag was missing. It was a chilly evening, and I had my thick woollen scarf on my lap and had put the bag at my feet. The café was very crowded and I felt the blood draining from my face. My friend's husband was quick to handle the situation, calmed me down first, and then we made our way to the Garda station. The waitress in the café had mentioned that there were some pickpockets operating in the area, before kindly handing me some money my friend had paid her with to use to get home, adding that I should "Take care."

Feeling very insecure and quite upset, I took the train home. The journey seemed much longer than usual. My husband, who

I thought would blame me for not looking after my bag, said consolingly, "So good you are safe." I had to make phone calls to all the bank and credit card companies, as my friend had told me to do, to cancel all the cards. Then we had all the locks changed in the house on the next day. And that I thought was that. I did reflect on what the Garda officer had told me, that foreign tourists, especially older ones, were an easy target.

Some days later I received a phone call. It was a man working at a refuse disposal centre in the outskirts of Dublin. He explained that he had found a handbag, and from the business cards inside had tracked me down. He said that there was a box of some twenty colour-slides, pictures of art of some sort, and that the bag was somewhat worse for wear on the outside, although the inside was fine. Of course the wallet was missing.

I was lost for words at the thoughtfulness of the man. The bag must have been ditched somewhere in Dublin, picked up and transported to the refuse centre, and must have somehow caught this worker's eye. The next day, my husband and I headed to the huge refuse centre. It took nearly an hour to get to the place. The guy showed up in his grimy work suit, and had my beige bag in his hand. He recounted how he had spotted my bag while moving refuse on a bulldozer. He stopped to check what was inside, and then had given me a call on his break.

When I looked around and saw the enormous waste site, I realized what a kind and conscientious person this man was. I made a deep bow of gratitude, and gave him a small reward to express how thankful I was. Although I had had reasons to be impressed with the kindness of the Irish on many an occasion, I had never been moved like this before. I've used this precious set of slides in my lectures many times since, and each time I remember how lucky I was.

Chapter 12

Reunion with My Daughter in Tokyo

EMA, MY DAUGHTER WHO was born in Dublin, lived in Japan for a few years after graduating from Trinity College. She had spent six months in Japan as a young child and, after that, had spent only a few short stays there. Through referral from an acquaintance, she got a job at Shoei Women's College in Takanawa in Tokyo, teaching English, and also participated in Anglo-Irish literature seminars at Waseda University. She stayed at my sister's house in Seijō, helping around the house, teaching English to her cousins, and really enjoying her days in Tokyo.

One summer afternoon, on her way home after work in Takanawa, she got off the train at Shinjuku to go to the Kinokuniya bookstore. There was a large crowd gathered in front of the store. As she approached, she found a foreigner busking and interacting with the crowd. He was playing a tune on a bagpipe (uilleann pipes), and was getting the assembled crowd to try and guess the name of the tune. The crowd in turn were enjoying this. In the early 80s in Tokyo the sight of a busker was rare, let alone one playing such an unusual instrument.

The red-haired young man was clearly enjoying the reaction people showed when playing popular Japanese tunes, children's tunes, and some foreign folk songs. At his feet though, the instrument case held only a few coins.

Ema was curious. She paused and listened, and soon recognized the familiar Irish accent. Then he called out,

"I'm sure no one can guess this next tune!" and started

playing "Amhrán na bhFiann," the Irish national anthem. Ema waited until the end of the song, and when no one spoke up, she said, "Irish National Anthem, isn't it?" He was so startled that he nearly dropped the instrument as he looked back at her, and then broke out into a big smile.

As they had a friendly chat, some of the people asked her in Japanese whether it was acceptable to put money in the case in front of him. As the question was asked in all seriousness, she replied that it was good manners to do so in Europe. Soon people started to carefully place money in the case. To each donation, he responded "Arigatō." He told Ema that he was delighted by this marvellous encounter.

Ema, having remembered why she had got off the train, went into the store to get an English book she needed. While strolling around the travel section, her eyes were drawn to a very familiar compact book, the Bus Éireann timetable! It provides details of the inter-city bus services in Ireland, and this copy was only one year old.

At home that evening, she mentioned to her cousins how surprised she was to find this, but they said that it wasn't really surprising. Travel writers, or even people just interested in travelling, loved to buy that kind of book. My daughter was suitably impressed with the broad variety of things that you could get in a Japanese store.

When Ema was still in Japan, I happened to need to make a business trip to Hiroshima and Fukuoka to tend to some exhibitions taking place there. When I was finished, I visited Ema in Tokyo. Since we hadn't seen each other for some time, we had a lot to catch up on. We were having some green tea, and to go with it I opened a box of Japanese confectionery, which I had received from a friend in Fukuoka. They were called egg vermicelli (Keiran sōmen) and indeed the moist yellow confectionery only made of egg yolk and sugar and

drawn into thin strands did look like angel hair pasta. They were so exquisite and delicate that it seemed a shame to cut them with a knife. Ema, who was making the tea, exclaimed that she had had something exactly like these in Portugal with coffee, and that they were yummy.

She explained that she had come across this delicacy, used as a cake decoration, while travelling as an interpreter and guide in Portugal for a Japanese couple. I glanced through the leaflet enclosed in the box and learned that the sweets had originated in Portugal and were introduced to Japan in the late sixteenth century by merchants and missionaries, just like another cake much loved in Japan called kasutera (pāo de Castella, a sponge cake). We enjoyed the sweet a little bit more, knowing the journey it had taken to get onto our plates.

And as for the Japanese couple that Ema had travelled with in Portugal, it should not surprise you to know that this was none other than Mr and Mrs Shigeo Sorimachi, the antiquarian bookdealer who was so benevolent to the Chester Beatty Library.

Chapter 13

Remounting Prints, Illness, and the Surimono Catalogue

As I've said, Sir Chester Beatty made specified terms before donating his collections to Ireland. One was to draw up a complete catalogue of the collections, and another was to maintain the library to house and exhibit these items. From the spring of 1970, I helped in the work of cataloguing the collection as an unpaid assistant.

We first set to work on the ukiyo-e prints, the surimono prints, and many printed books, altogether amounting to nearly a thousand items. It was impossible to complete the task to anything near perfection as there were so many factors to be researched, including the compiling of accurate bibliographical data. At around this time the CBL hosted the First International Research Conference on Illustrated Japanese Literary Texts in 1978. The gathered researchers and scholars were astonished to find that there were no worthwhile reference books or materials at the library, yet it housed superlative objects of Japanese art. The only things available were my dictionaries and a few ukiyo-e catalogues.

During one of the breaks at the conference, several participants gathered in my room to help list a minimum set of books that would be required. They detailed the name, author, publisher, and approximate price. It was obvious that the library would not be in a position to afford the expense to purchase these, so I turned to the Japanese embassy for help. The press and cultural officer there, who knew well the situation I worked in,

made a grant application to the Commemorative Organization for the Japan World Exposition '70; this was an organization that subsidized a variety of cultural activities. Shortly afterward we received the delightful news that the application had been accepted. Even before the grant became available to purchase the books, some packages had started to be delivered to the library. These had been sent generously by some of the researchers who had attended the conference, or were presentation copies from publishers that they had contacted. It didn't take long for the much needed Chester Beatty Research Library to be born, and the knowledge gleaned from the books was put to good use in the cataloguing work.

There was another distressing issue that we had to tackle, namely the very poor condition of the print mounts. The prints were protected by nothing other than aged cellophane and urgently required proper remounting. The reputation of the collection had begun to spread, and the library received exhibition requests from institutions across the US and Europe. It was not just the Nara ehon that were of interest; the ukiyo-e prints of fine finish, especially the surimono prints, were also in demand.

In fact, there were requests for one particular item: a large-sized original surimono print, reputedly the last one existing anywhere. I had anticipated that there would be interest, and had been sending applications to the Japan Foundation at every opportunity to fund a grant to remount the collection. But so far it had been in vain. Then, in 1979, a year before the Hokusai exhibition was to be held in Paris, we received some great news from the embassy. The press and cultural officer told me that the Ireland Japan Economic Association as well as the Japan Business Society in Ireland had agreed to fund the restoration work of the ukiyo-e prints and an expert would be coming from Japan to work at the library.

In the early spring of 1980, the eagerly awaited conservation expert, Mr Takao Endo from the Tokusuiken studio of Tokyo,

arrived in Dublin. He stayed for one month and started on the restoration work as well as teaching the basics to a set of volunteers comprising a student from the National College of Art and Design, Mr Raymond O'Brien, four Japanese wives whose husbands worked for companies in Ireland, as well as myself. The first task we set ourselves was to remount the Hokusai prints, which were to be exhibited in Paris shortly. And by some miracle we finished that work in time. Jan Chapman took care of the transportation to Paris, while I prepared the commentary for the exhibition catalogue in English and had this translated into French. That first month passed very quickly and Mr Endo left Dublin. Over the next six months we were on our own and managed to complete the project; we remounted the rest of the ukiyo-e prints as well as the surimono prints. At this stage I had no idea that the painstaking work was resulting in a strain on my body.

When the Hokusai exhibition was coming close to its end, I travelled to Paris to meet Dr Roger Keyes, an eminent ukiyo-e researcher and an old friend. He was already mulling over an idea to produce a catalogue of the library's surimono print collection. This would be realized in 1985 with the publication of *The Art of Surimono*. Returning to Dublin, I started the preparation for this catalogue while completing the remounting of the thousand prints. While the work was very challenging, it was also quite an education for me. At his suggestion, we tackled the translation of the comic tanka-style poems (kyōka) and the humorous haiku poems (senryū) that were a feature of surimono prints. It was very much a collaborative effort with Professor Susumu Matsudaira, a researcher of ukiyo-e prints and dramatic narratives at the University of London, and Mrs Keiko Keyes.

While I was totally caught up in the hectic but exciting work, one day I noticed something strange in my physical condition. It didn't go away, and I began to get a little anxious. Pushed

by my family, I went to see my doctor. He examined me and recommended that I see a specialist for further examination. After some tests, the specialist announced that I would need to have a kidney removed. This was totally out of the blue for me. As he explained what this entailed and where it could be done, it was all I could do to keep silent and just keep nodding.

When my husband brought me home from that consultation, I was in shock. So was Satoshi. I phoned my elder brother, a doctor in Japan, to talk it over and to ask for advice. "You must come back to Japan right away," he ordered. "I'll make a reservation at Tsukuba University Hospital for the operation and treatment." I managed to thank my brother for his thoughtfulness for a younger sister who had long ago moved far away to Ireland; I hung up the phone while trying to fight back tears. We knew so little about the quality of medical care in Ireland.

We began to ask around and find out more. It turned out that the specialist who would be performing the operation was a reputable urologist in Ireland and had spent some years training at the Mayo Clinic in the United States. My husband's colleague at UCD, who had medical connections, convinced me of his reliability by saying that there would be "no worries at all." Once that was settled, it all went very quickly; I was hospitalized soon after, and the operation was scheduled for seven o'clock in the morning of the following day. In those days it was classed as a major operation, requiring my abdomen to be opened. On the night before, I felt a little anxious, but eventually settled into a good sleep. I showered, and then was transported on a gurney to the operating theatre. On the way I answered some questions that the nurse asked me, my name, age, place of birth, and such like. But I remembered very little from that point.

In the evening, when I woke up from the anaesthesia, I was surprised to find at the bedside my family, who had rushed to the hospital when they had received the call from the surgeon.

There was a small forest of flowers sent from friends and acquaintances. My husband and children were smiling as they listened to the surgeon, who explained that things had gone well.

"No worries, since you have another kidney left. Please take good care of it," he said gently, smiling down at me. I thanked him through tears.

After spending less than a week at the hospital convalescing, I was discharged. I was glad that I managed to walk steadily the very short distance from the hospital entrance to where my husband had parked the car. Back at home I phoned my brother to reassure him that all had proceeded well. He was surprised to hear that I had been discharged so quickly compared to Japanese practice, and he sounded relieved to hear the strength in my voice. At the hospital, in the morning and evening, two sister nurses had knelt and prayed at my bedside for a quick recovery. I heard that my husband's colleague, Dr Ivo O'Sullivan, had also said a daily prayer for us. All in all, the experience, both good and bad, remains precious and unforgettable for me.

Following the doctor's advice, I took a two-month leave from work at the Chester Beatty Library. I remained at home, resuming some work little by little there.

I had a follow-up examination one year later, and it showed that I had recovered well, which was a great relief to me. The doctor agreed that I could continue to work at the library, but told me to try and take things easier. In view of my age, he recommended that I undergo a gynaecological examination just in case.

I duly underwent a full check-up at the Department of Gynaecology at Trinity College where, to my horror, I was diagnosed with cancer of the uterus. Dr John Bonner, chief professor of the department, told me that my uterus and ovaries would need to be removed, and he assured me by saying "No worries." As it was my second operation, needless to say, I was depressed.

As time went by, I slowly managed to regain some calm and to ready myself for the operation. I gave a short account of this to my brother in Japan. He listened, and didn't insist that I return to Japan this time, which made me feel more cheerful. Thankfully, the operation was successful. For ten years after that Dr Bonner made a point of sending my brother a copy of the medical report each time he gave me an annual check-up. I doubt if one could find a doctor that would do that in Japan. Following Dr Bonner's strong approval, I resumed my work at the Chester Beatty post-operation for a second time.

Back at the library I found that even more work had been awaiting my return than I had anticipated. Each project was in a critical state. The Keyes's surimono catalogue production was in the final stage, so I travelled to London to work on the final proofreading at the publishing house, Philip Wilson. In the early spring of 1985, I received some copies of the surimono catalogue at the Chester Beatty Library. To commemorate the publication, a surimono exhibition was held, following a year of preparation. In March, the Crown Prince and Princess (now Emperor and Empress) of Japan paid an official state visit to Ireland, something I'll talk a little more about in a later chapter. To mark their visit to the library, the Director, Mr Lockwood, presented the first copy of the first edition of the catalogue to the imperial couple.

Following the publication of the catalogue, more requests to run a special exhibition of surimono poured in from various parts of the world. I was crying with joy, since there was now an excellent catalogue to accompany the collection. In 1987 another surimono exhibition was held in the outskirts of Boston. I travelled with Mr and Mrs Lockwood to inspect the exhibition and attended a lecture that Dr Keyes gave. To me, Boston was a place of fond memories, so I spent a day reunited with family friends from Harvard University. I just wished I had had more free time there. But I was obliged to fly on to

Japan to bring back the Chester Beatty Library items being exhibited at the Chūson-ji Temple, as the exhibition was, after a year, coming to a close. I also needed to prepare for the next project, entitled "Homecoming Exhibition," planned for the following year at the Suntory Museum in Tokyo. My work took me around the world, but I had to make sure that I stayed fit and well. I was very fortunate that I was offered so much help from friends wherever I travelled.

Chapter 14

Sake at Chūson-ji Temple

THE TIME DIFFERENCE BETWEEN Japan and Ireland is nine hours, eight hours in the summer. Because of this, I rarely received phone calls from Japan at work. But one morning, in 1986, there was an exception. When I was about to start work, I received a call from Japan. It was my old teacher, Professor Tsugio Miya. He usually rang me at home from his workplace at the college in Tokyo, but this time it was from the Chūson-ji Temple in Hiraizumi.

After a short greeting and pleasantries he immediately got to the point. He explained that they were preparing for an exhibition entitled "Minamoto no Yoshitsune" at the temple and asked me if they could borrow some items from the Chester Beatty Library. He was with Mr Kuniyo Sasaki, a monk, who was in charge of the exhibition.

I had to pause to collect my thoughts, and replied, "Please give me a little time. I'll try to persuade the board of trustees. In the meantime, please send an official request to the board specifying the items you want, and the terms. It doesn't need to be in English, Japanese is fine."

After I hung up the phone, I paused to reflect on the urgency of the request. There would be only one year to prepare for the opening day, while two or three years was a more typical timeframe. At the same time I was delighted that it would be a wonderful opportunity for the library to let the world, and especially Japan, learn of the excellent selection of Nara ehon residing at the little Dublin library.

One of the items they requested was a set of three scrolls, "The History of Musashibō Benkei." This was the masterpiece which had brought Professor Gensei Tokue all the way from Japan. For me it was the most significant book that had introduced me to the genre of Nara ehon picture books. Another item was "The Story of Yoshitsune's Invasion of Hell" (Yoshitsune Jigoku Yaburi). This consisted of two booklets and was categorized as Nara ehon too. The board of trustees accepted the request unanimously and specified some terms. One of these was that I would be given the responsibility of carrying the items to Japan and then returning them to Ireland. The terms were forwarded to Japan and accepted. I became busy with the necessary preparations, along with the other work I had to do. Despite the additional load, I was happy that the Chester Beatty collection was gradually becoming better known and recognized in Japan. At the same time, I realized that my responsibilities had grown greater. I was now in charge of managing the entire job of handling the necessary paperwork and transport arrangements to bring the collection to Japan and then to return them to Ireland.

As the date of the exhibition approached, I left Dublin with a specially prepared duralumin suitcase, which contained the two Nara ehon masterpieces. During the flights, the suitcase sat in the passenger seat beside me, as the trustees had required. After the lengthy flight, we arrived in Japan. At Narita Airport I went through customs and was greeted by Mr Hokurei from Chūson-ji Temple, dressed in his monk's regalia. It was already early evening by the time I got into the car that he had arranged, and as I slumped into the rear seat, I began to feel ever so slightly more at ease. At the Imperial Hotel we left the suitcase in the hands of the receptionist, making sure that it was secured safely. So finally, even for just a little while, I felt some relief from the responsibility that bore on me on the long journey from Ireland. The hotel that the temple had booked me

into was very impressive compared to the one I usually stayed at in Japan, but I had little energy to enjoy the luxury. I ordered a room service dinner and went to bed shortly afterward.

I slept well that night and was woken by a call from the monk, Mr Sasaki of Chūson-ji Temple. He thanked me for transporting the treasures to Japan. I felt refreshed and not tired. Mr Hokurei told me that he had stayed at some accommodation in Tokyo owned by the temple, and came to pick me up at ten as agreed. He was dressed casually this time, not in his monk's frock. We fetched the suitcase from reception and headed to Ueno Station. We got on the Tohoku Shinkansen bullet train, which had only recently started operations. We made our way to our seats and Mr Hokurei went off to buy our bento lunches. He put one of the bento boxes and a copy of the well-respected *Weekly Asahi* magazine on the small table at my seat. He also brought some oolong tea for me. I looked across at his table, where he had a can of beer and a copy of the somewhat more sensationalist *Weekly Shincho* magazine, and I could not help smiling to myself. We enjoyed the view of the countryside flashing by, and presently arrived at Ichinoseki Station. From there we were driven in a car sent from the temple, and headed to our final destination, Hiraizumi.

Over the next week we were busy making final arrangements and preparations for the exhibition, and the time passed very quickly. Joining me were Professor Tsugio Miya and some curators from different museums in Japan, as well as an expert from the Agency of Cultural Affairs. We were all booked into the same hotel. During breaks from the hectic schedule, we managed to find time to visit Mōtsū-ji Temple and some other historic places in connection with the Ōshū Fujiwara dynasty. We enjoyed listening to stories relating to Yoshitsune. Professor Rikuro Ishikawa of the National Research Institute of Cultural Properties had made a special arrangement for Professor Miya and me to gain entry to the Golden Hall (Konjikidō) at Chūson-

ji. This was really fascinating. We listened avidly to the expert explaining the complexity, craftsmanship, and artistry used in the hall. All of this was so exciting for me and I remember this still so well.

In the meantime, the work of preparing for the exhibition proceeded smoothly. The paintings relating to Yoshitsune and the other items were put in place, and we readied ourselves for the opening day with a burgeoning sense of relief.

The exhibition was opened with a majestic ceremony befitting the eight-hundredth anniversary of Lord Hidehira Fujiwara. It was followed by a magnificent reception. Numerous sake barrels were opened, and this was best quality sake worthy of the occasion. As I sipped a cup of it, quenching my thirst, Mr Hokurei noticed and exclaimed, "Oh, Mrs Ushioda, you can drink?!" I recalled the oolong tea he had bought for me on the train, and I made a toast to the people with me.

The time passed quickly and felt a bit like a dream, but soon I had to leave the Chūson-ji Temple to return to Ireland. I promised to come back to retrieve the treasures for their return to the Chester Beatty Library once the exhibition finished. Before I left, I was presented with two gifts: some lacquerware made in the Hidehira style, and a small cask of sake wrapped in a rush mat that had been specially prepared for me.

Chapter 15

A Meeting with a Japanese Writer in Dublin

IN 2009, THERE WAS a Japanese drama series broadcast on NHK entitled *Clouds above the Hill*. It was an adaption of the historical novel masterpiece on the Russo-Japanese War written by Ryōtarō Shiba. In the wake of this, emails and letters started to arrive, a little to my surprise, from people that I had lost contact with for some time. Although it was almost thirty years since his *Travels in Ireland* (Ireland kikō) had been published, one of many in the much admired book series *Travels by the Old Highways* (Kaidō wo yuku), it still brought me back to the day when I had met the author Ryōtarō Shiba here in Ireland. Unfortunately, he passed away about two decades ago, and on this anniversary, February 12, there is a commemorative gathering every year called the "Rape Flower Memorial." I usually send his favourite yellow flowers and indulge in some reminiscences here in Dublin.

It was late March 1987 that I first met Ryōtarō Shiba. At the time, I was interested in widening my knowledge of Japanese literature, which was deeply connected with the art history I was studying. I took part in the Japanese Literature Seminar at Cambridge University in the UK. On the last day of the seminar, a special lecture was announced with the famed novelist Ryōtarō Shiba as speaker. I hastily rearranged my flight so that I could remain in Cambridge to attend. As I entered the hall, I was surprised to see how crowded it was, and that additional chairs were needed to accommodate everyone. Ryōtarō delivered his speech in his usual relaxed manner, and

mentioned several times that he was on a stopover on the way to another destination. This remark puzzled the organizer of the seminar, and he questioned Ryōtarō about this. He revealed that he was embarking on a project in Ireland, and asked if there was by any chance anyone from Ireland in the audience. I had a moment's hesitation, but slowly raised my hand, encouraged by several friends seated nearby who knew I lived there. This caught the eye of Mr Satoshi Asai, the editor accompanying Ryōtarō. As the lecture finished, he came over and told me that they were heading to Ireland after the lecture and asked me if he could get my address and phone number. I wrote these down and handed them over, and explained that I was not at home several days a week because of my work at the museum.

A few days later I received word that Ryōtarō and his party had arrived in Dublin. The following morning Mr Asai called me and asked me to come over to the Gresham Hotel, together with my husband. We arrived there at the appointed time.

Ryōtarō was already seated on the sofa in the far corner of the hotel lobby, and greeted us in an enthusiastic manner. He started by apologizing for his impoliteness at the Cambridge lecture. "I was delighted to be able to find someone from Dublin." To the Cambridge audience he had merely said that Ireland was the destination, but had not explained why. "Ireland is the land of my dreams. I love Ireland." He continued by raising comparisons between pre-war Korea and Japan, the Basque country and Spain. "I like underdogs. That's why I've been longing to visit Ireland." Very much to our surprise, he had done his homework about us. He knew my husband's name, workplace, and profession. He even knew when we had moved to Ireland. Needless to say he had done an enormous amount of research on everything about Irish history, literature, and other cultural aspects of the country. It was no exaggeration to say that he was in Ireland to verify what he had learned about the country. Although I knew that he usually prepared and planned

with extensive research before travelling, I realized that this was beyond any normal expectation. In 1989, a year after *Travels in Ireland* was published, I had an opportunity to visit him at home in Japan. There I was stunned at the vastness of his library and its diverse range of materials, comprising all the books and documents that he had gathered and studied in preparation for his various journeys.

At the Gresham he continued, "You might find some faults with what I've learned about Ireland, and please don't hesitate to correct them." We felt astonished and humbled by this remark, as everything he said was so accurate and coherent that we could not find fault with any of it. On the subject of films, he said "*The Quiet Man* is my favourite film, so we'll certainly visit the areas around Galway. I read that there's a magnificent hotel in the town of Cong, is that right?" He also asked about our own lives, and how we liked living in Ireland for a long period of time, and whether we had experienced any troubles living abroad. We replied that we could not have been more fortunate as the people around us had been so kind to us. He nodded deeply and responded, "It sounds like the Ireland I was expecting." And he followed up on several occasions with "It's a good thing to know."

"It's excellent that you take part in seminars like the one in Cambridge. I can imagine that your work in the library is demanding, but it's wonderful that the Japanese literature you studied in college still has a place in your work after all these years spent abroad. Studies like Japanese literature would indeed serve a more useful purpose abroad than in Japan." This compliment has become one of the leading encouragements for me in my work.

Shortly afterward he left Dublin in a minibus to visit the rural areas for his research. Mr Yoshiaki Iwai, a friend from *Sankei Newspaper*, accompanied him and they travelled around the south and west, including the Aran Islands, a place that

he had longed to visit. These trips are colourfully described in *Travels in Ireland*.

He arrived back in Dublin after about ten days. Mr Asai, the editor, contacted me saying that Ryōtarō had been invited to pay a courtesy call to the president. He wanted me to accompany him, as he was not comfortable on formal occasions. President Hillery was a medical doctor and well-known for his friendliness. However, Ryōtarō, despite feeling honoured at the invitation, wanted to avoid this kind of occasion. In his book he explained, "It would be a strain for an uncouth person like myself, but it was Mrs Yoshiko Ushioda from Dublin who talked me out of this reluctance." To tell you the truth, I too paused for thought before persuading him to attend. Furthermore, in the following days there was news that the president's daughter had passed away, having been under medical treatment. Ryōtarō asked me to cancel the visit as he thought it might be inappropriate at such a time. I conveyed this message, but the reply came that the president was interested in meeting Japanese people in particular and wished us to attend.

I picked up Mr and Mrs Ryōtarō Shiba from the Gresham and we headed to the Áras an Uachtaráin (official residence of the Irish president). We also collected some flowers that Mrs Shiba and I had made into an arrangement beforehand. We entered the Áras, feeling a little stressed. Ryōtarō offered his condolences to the president and then introduced me, explaining how we had met and the work I did. We were ushered into a room where tea was served, and soon felt relaxed. At once Ryōtarō began to explain in detail why he was so interested in Ireland and what he was researching. He had a polite and friendly manner and never stopped smiling. This created a naturally relaxed atmosphere in the room. He continued saying that Ireland was the land of his dreams and that he thought of himself as a fortunate person to be able to visit the country. He related his experiences on the Aran Islands, laughing as he explained that he had had to crawl

on hands and knees to keep from being blown over by the gales.

The president listened attentively and smiled as he explained that he knew the situation well, as he himself was from the West. The relaxed, pleasant conversation continued over the tea and cakes set out on the table. The president moved on to talk about Japanese culture, as he had made an official visit to Japan a few years previously. The president explained that he loved Japan; in particular that the Noh play he had seen there had made a strong impression on him. Ryōtarō was deeply impressed, saying that he would not expect talk of Noh plays on a visit to the president. The president explained that the Irish have an affinity for Noh plays, and that William Butler Yeats had been so enamoured with them that he had become very eager to visit Japan, though sadly this didn't happen. "But I was able to go and see what he could not." The state visit to Japan had taken place immediately after the National Noh Theatre had opened in Tokyo. "Did you have a chance to see any Noh plays while living in Japan, Mrs Ushioda?" I was startled slightly that he had directed the question to me. I dragged up old memories, and mentioned that I had seen several at the Hosho Nohgakudo Theatre in Suidobashi while in college, and recounted how we had to write a report after every visit. The president was enjoying this topic of conversation and stretched it out for some time. He repeated, "I was able to see the Noh plays that Yeats was so desperate to see . . ."

We moved on to the subject of the Shika deer that roamed the garden and outlying park of the Áras. He explained that the Shika deer is a cross between Japanese and native deer. His wide knowledge so impressed Ryōtarō that he portrayed this episode amusingly in the *Travels in Ireland* book.

Even after he returned to Japan, Ryōtarō continued to send me many questions. While we were waiting for his delayed return flight on his journey home to Japan at Dublin Airport, he would not let us off the hook and continued to ask questions.

"Please tell me about Lafcadio Hearn (Koizumi Yakumo), as I didn't have much time to study him on this trip. I should have done more to study him when I wrote *Ireland, The Land of the Fairies*. I'll do more research for this next book when I get back to Japan. How is he received here? What do the Irish think of him?" When I finally read *Travels in Ireland*, published after his return to Japan, I found the life of Lafcadio Hearn recounted in it, and felt impressed at the research he had carried out on his return. Originally, Ryōtarō had not had much interest in Lafcadio Hearn, as his mother was Greek. After finding the Irish connection, in particular with the fairies in Ireland in his work, he seemed to regret that he hadn't covered this subject properly in his earlier book and so took time to redress this.

Since the TV drama *Clouds above the Hill* was aired on NHK, I've heard that his other works are making a comeback in popularity. Quite often tourists and visitors from Japan ask me whether I'm the one mentioned in his books on Ireland. They ask me where else he travelled, apart from Dublin and the Aran Islands. I heard he had visited most of the locations where films had been made, such as Dingle, where *Ryan's Daughter* had been filmed.

I've noticed that some Japanese visitors (not just Ryōtarō) who are experts in Irish literature have a remarkable geographic knowledge of Ireland before they even land in the country. I remember a particular visitor was able to give us precise directions, turn by turn, as my husband drove the car. And he was anxious to make corrections upon his return to Japan, when a particular detail turned out to be wrong. These are precious unforgettable things that I've been able to experience, thanks to ending up living in Ireland. To quote Ryōtarō Shiba's phrase, I think of myself as a fortunate person.

Chapter 16

The CBL Collection's "Homecoming"

THE JAPAN AIRLINES FLIGHT JAL 402, direct from London, touched down safely on the Narita Airport runway. I took a good stretch, feeling relieved after the long flight. In the next moment, a flight attendant came up to me to confirm my name, and the feeling of stress returned, as I was reminded again of the purpose of this journey. It was no ordinary trip, but a mission to deliver sixty-five precious artworks belonging to the CBL. I was with Mr Satoru Sakakibara, a curator at the Suntory Museum. He had come to Ireland so that we could travel together to share the responsibility of transporting the treasures. Immediately upon leaving the plane, I noticed that we were being filmed by NHK TV crews. Although it was too late, I hurriedly tried to fix my untidy hair and headed to the arrival gate. The Irish ambassador was there to greet us. Because I was conscious that we were being filmed, my English seemed to desert me as he welcomed us. Instead, perspiration seemed to burst out under the summer humidity and the heat from the TV lighting. This was June 28, 1988.

The "Ireland's Chester Beatty Collection: Tales of Japan" exhibition was to be held at the Suntory Museum and some other venues, and this is what brought me to Japan on this occasion. The sixty-five items from the library's collection were to be exhibited in response to the increasing interest in Nara ehon and Otogi Sōshi in Japan. To tie in with this exhibition, NHK Educational Television was producing a special programme featuring the CBL's excellent Japanese picture books and scrolls

from the medieval and early modern period. Another feature of this programme was to convey the role I had played in the library. In addition to the clips that they had already filmed in Dublin, they were to record my time in Japan, from my arrival, through the unpacking and preparations and so on.

Since 1970, when I set out on organizing and cataloguing the collection, I had put my entire heart and soul into the work. Having started from scratch with no training in Japanese art history, in a milieu where there were no relevant documents or books available, I spent days and nights learning everything from on-the-job experiences. As I look back now, I'm amazed how far I have come down this long path. During the first ten years as a volunteer, followed by eight years when I finally got permanent employment in 1980, I would not say that everything had happened without a hitch. I had been seriously ill twice, and I had found myself dragged into conflicts amongst colleagues, which had given me serious pause for thought as to my future. When I thought about what kept me going, I came to the realization that it was the greatness of the collections at the Chester Beatty Library. I appreciated Chester Beatty's vision to present his great collection to Ireland for future research so that its treasures might not be scattered around the globe. As I've mentioned earlier, the main features of the collections are Islamic cultural artefacts including Persian and Turkish paintings as well as Mughal miniature paintings. His Japanese collection, although outnumbered in size by the Islamic collection, includes precious treasures that are so valuable to any student of Japanese art, literature, or history. Unfortunately, or fortunately for me, this small library had no Japanese art specialist at the beginning. That's why an apprentice like me was allowed to sort out the collection. In that time there had been quite a few challenges and setbacks in the work of cataloguing and publicizing the collection. Taking this into consideration, I felt that this display of CBL Japanese artworks in the Suntory

Museum was in a sense a "homecoming exhibition," and it was a significant milestone on this path.

In the early days there had been times I had thought of taking time off from housework and going back to continue with some formal studies to assist me. But it would have been difficult to leave my husband and children behind in Dublin. One way might have been to take intensive lectures and seminars, but even without that because of my work my family were making sacrifices to support me. As I look back now, I find that I had been blessed with opportunities to learn here at the CBL, with the genuine articles in front of me, from the best teachers and experts from every corner of the world. They taught me so much more than any formal college might have, and I felt so fortunate. Somehow my knowledge of Japanese literature from college had laid the base, and had proved unexpectedly useful abroad. The little informal lecture that Professor Rosenfield of Harvard had given me at the Fogg Museum was the first step on a long journey, and it had finally borne fruit, helped by the goodwill of so many experts.

On the sixth of September in 1988, the "Tales of Japan" exhibition had a grand opening at the Suntory Museum in Tokyo. The CEO of Suntory, the Irish ambassador to Japan, and the chairman of the board of trustees of the CBL were among the invited guests as well as Imperial Prince Mikasa, who performed the ribbon-cutting ceremony. During the reception, Prince Mikasa, who was an Ancient Orient scholar, enthusiastically asked me many questions about the library's Middle Eastern collections. We also talked about a special history lecture he had delivered at my college, Tokyo Women's Christian University, in the fifties. He gave me words of encouragement, saying "Please pursue your work and take good care of this great collection."

Two days later, another imperial couple, Prince and Princess Takamado, came to view the exhibition after closing time. Together with Professor Tsugio Miya, I had the honour of

showing them around the gallery. During this visit, the prince told me that he had heard a lot about the Chester Beatty collections from the Crown Prince, and that he had been looking forward to the occasion. As a matter of fact, in March 1985, when the Crown Prince and Princess had paid an official visit to Ireland, I had had the honour of showing them the library's collection. It was one year after I managed to resume my work, having suffered two serious illnesses in succession. In the face of family opposition, I had been of two minds about returning to work. It was my surgeon, who had a very empathetic approach, who told me that the most important thing for a full recovery was to have fuel for living. For me, that was the work that I had had to leave unfinished at the library. Had I not returned to the CBL then, I would surely not have been able to see this successful opening as well as other events that have made me proud and happy.

The programme that the NHK were producing included a roundtable talk filmed in one of the studios. Amongst the panellists were Mr Sakakibara of the Suntory Museum, Professor Tokue of Kokugakuin University, Professor Miya of Jissen Women's College, and myself. Before filming, we sat down and went through some photographs that I had brought from Dublin that we would use on the show. Professor Miya was startled at one of the photographs, and exclaimed, "This is my father!" This photograph had been taken in 1917 during a welcome party for Sir Chester Beatty and his family in Japan, arranged by Mr Sadajirō Yamanaka from the Yamanaka Company in Osaka. The photograph showed Sir Chester with his wife and their daughter dressed in a kimono, as well as Mr Yamanaka sitting with geisha girls between them. At the very left, dressed in a kimono, was Professor Miya's father. Professor Miya, through smiles and tears, said "I've never seen such a photo of my father." This scene remains with me. According to him, his father had worked for the Yamanaka Company,

and he visited the New York and Boston branches. It was quite
something to think that the foundations between the Chester
Beatty Library and Japan had been laid in 1917.

The NHK programme was broadcast on September 21
while I was still in Japan. I gathered that the NHK and Suntory
Museum had received a considerable number of enquiries
about me. The telephone at my hotel, the Kayukaikan, kept
ringing. There were calls from people I had known from
primary and even nursery school, as well as from the times of
hardship during and after the war, when I was at school. Other
calls were from friends I had made in the US or Ireland. They
must have been surprised to see me pop up all of a sudden as I
wasn't even in a reunion list due to a long stay abroad. I think
it caused a bit of a stir. Over the next ten days or so, I enjoyed
renewing friendships with so many people from the past. And I
was startled to discover the power of television.

The exhibition moved venue to Kobe and then Nagoya
and came to an end on January 16 the following year. On the
last day over a thousand people came to see the exhibition. I
travelled back to Japan for the close of the exhibition, this time
together with Jan Chapman, so that we could undertake the big
responsibility of transporting the treasures back to Ireland. The
next day, helped by the curators of the Suntory Museum, the
Nagoya City Museum, and experienced movers from Nippon
Express, we took down the exhibits and carefully checked each
item. In the late morning, I was told that someone from the
Imperial Household Agency was on the phone, and was asking
for me. As I went to pick up the call in a corner of the large
gallery, I overheard one of the curators saying that it was probably
a request for a photo shoot. It was one of the chamberlains to
the Crown Prince and Princess, and he said, "Congratulations
on the completion of the successful exhibition. Due to current
circumstances, we are not able to mark it with anything special,
but I have been asked to tell you that they have appreciated

the work you have done." As I listened to this, I found myself making a deep bow as the people in the gallery looked on. It was just ten days after Emperor Hirohito had passed away. During the second week of the exhibition at the Suntory Museum, the Emperor who had been ill took a severe turn for the worse. As his condition deteriorated, the Japanese had gone into a mood of respectful self-restraint, and this had cast a somewhat gloomy oppressive air over the entire nation. The duration of the exhibition coincided with the last four months of the Showa period, Emperor Hirohito's reign that had spanned over sixty years. Needless to say this sense of the end of an era made the exhibition even more unforgettable for me.

Among the stories of this exhibition, I would like to write about one that left a strong impression on me.

For the opening of the exhibition, Mr Walsh, the chairman of the Chester Beatty Library's board of trustees, had been invited together with his wife, by the Suntory Museum. This was their first visit to Japan. Since late June I had had a hectic schedule in preparation for the exhibition, including a trip to Kyoto. I finally travelled back to Dublin, and helped Mr and Mrs Walsh to make the various arrangements for their trip.

At Narita Airport, the Irish ambassador, Mr Sean Ronan, and the Director of the Suntory Museum, Mr Yoshio Tsuchiya, welcomed us and we headed to the Hotel New Otani in Akasaka, Tokyo. At the hotel we were briefed over a light supper, and Mr Tsuchiya handed Mr Walsh his itinerary and a white envelope, saying, "Please enjoy your first stay in Japan." It was already late at night when I finished the tiring duties of an interpreter and headed back to my hotel.

The following day, I took Mr and Mrs Walsh to the museum, where the preparations for the exhibition were finished and everything was ready for the opening. That evening we were invited to a welcome dinner given by Ambassador Ronan at his residence. As I was concerned that they were on a very busy

schedule over the next few days, I brought them back to the hotel early.

After the grand opening of the exhibition on September 6, a dinner party was given by the CEO of Suntory, followed by a concert at the Suntory Hall. It was so magnificent that it truly impressed the Irish delegates. After the series of official engagements died down, we received a suggestion from Mr Tsuchiya to make an overnight trip to Nikkō. I agreed with him that it would make the perfect attraction for the couple to visit as a memory of Japan. It was also the place where Sir Chester and his family had spent a summer in 1917.

When we arrived at Nikkō, Mr and Mrs Walsh appeared deeply moved to set foot on the same ground as Sir Chester so many years ago. It was still a little early for the autumn colours, but it was nevertheless a perfect sightseeing spot. We checked into the Prince Hotel, and took a stroll in the beautiful garden as we made plans for the next day. I told them the Japanese aphorism, "Don't use the word 'marvellous' before you've seen Nikkō," referring to the most famous sightseeing spot, Tōshōgu Shrine, in the area. Then Mr Walsh taught me the English equivalent, "See Naples and die." The three of us had a relaxed but fun time, talking, joking. Mr Walsh, who had an extremely busy life back in Dublin, told me that he was delighted to come to Japan and that he hadn't had such a wonderful holiday for a long time. When he thanked me deeply as we shook hands, he no longer seemed to be the unapproachable authority to an ordinary library curator.

On the following day we toured Lake Chuzenji and then through the magnificent cedar forests down to Nakasendo Avenue. The late summer sunbeams streamed through the still-fresh green leaves, and cast shadows and sunbursts along the way. We visited the famous waterfalls and magnificent Tōshōgu Shrine, together with the crowds of other people at the popular tourist sites before we headed back to Tokyo.

That night the Walshes hosted a return dinner for Ambassador

Ronan and his wife at the Tokyo Imperial hotel. I had intended not to go, since they didn't need an interpreter. Yet they insisted I attend. We toasted the couple for having been able to make the journey to Japan despite a busy schedule at home, and also for a safe trip home.

The next morning, I went to their hotel to bid farewell. They were already waiting for me in the lobby. I thanked them deeply for coming to Japan and for taking time out from Mr Walsh's busy work schedule. I began to feel slightly lonely. Mr Walsh handed me an envelope and asked me to give it back to Mr Tsuchiya.

Later that morning, I visited Mr Tsuchiya at the Suntory Museum to thank him as well as to tell him about the trip to Nikkō. I handed him the envelope from Mr Walsh. In it there was a handwritten thank you letter and the balance of the money he had not spent during the stay.

Mr Tsuchiya was astonished, and exclaimed, "Mrs Ushioda! What do I do? This has never happened before!"

Perhaps his parting action should not have been surprising, since Mr Justice Brian Walsh was an esteemed judge who served the Supreme Court in Ireland for many years as well as the European Court of Human Rights in Strasbourg—in short, a man of principle.

Chapter 17

Visiting Old Kyoto

PRIOR TO WHAT I call the "Homecoming Exhibition" (Ireland's Chester Beatty Collection: Tales of Japan) at the Suntory Museum, I paid a visit to Kyoto, where Sir Chester Beatty had purchased many of the picture scrolls and other art objects seventy years ago. In the graceful historical city, I passed by rows of houses with lattice windows, the patina looking even darker in the wetness of a sudden downpour. As I strolled off the busy main street and turned a corner, I reached a narrow bystreet, with a quaint name that was uniquely Kyoto. I listened in silence to some cars as they passed by, and there was also the rhythmic clatter of a loom in the distance. The feeling of the refined old imperial city calmed my mind that had strained somewhat from long years of living abroad. Passing through this time tunnel, I decided to visit some of the antiques dealers that Chester Beatty might have visited some seventy years earlier in the hope of finding some of the origins of picture scrolls.

It was a well-known fact that many Japanese culture assets had been brought overseas during the Meiji and Taishō periods. For example, ukiyo-e prints, which the Japanese did not value, had been exported in volume at unimaginably low prices, and had gained popularity in the West, hugely influencing the Impressionist painters at the time. It was similar with the picture scrolls of the kind that were being exhibited in the "Homecoming Exhibition" at the Suntory Museum. These were not so popular during the Taishō period when Chester Beatty would have been making purchases.

When I had begun working as a volunteer at the Chester Beatty Library in 1970, it was generally held that most of the items in the Japanese collection were acquired in his later years. But during the International Conference on Nara ehon picture books held in Dublin in 1978, quite a few researchers began to question this assumption. As I mentioned before, Mr Sorimachi, who had watched the art market keenly as an antiquarian bookdealer, remarked that he had never seen these items in the Japanese market. He felt that they must have left Japan at a very early stage. He asked me to investigate when and how Chester Beatty had acquired the items. This difficult request had been etched in my mind over the years. During lunch or coffee breaks I checked anything and everything in old cabinets or randomly piled boxes in an attempt to find some clue. One cold winter evening, the breakthrough happened suddenly.

I discovered a bunch of what turned out to be precious files in one of the cabinets placed in a dark corner of one of the rooms. They were in a large brown envelope, which seemed never to have been opened since it had been brought from the UK. I opened the files, checking them one by one, hoping that something in there might be the information I had been looking for. Then I found something that left me speechless.

It was a thick, large sheet, an Application Form for the Export of Art Objects. The items denoted were all familiar ones that I had seen so many times while the Sorimachi catalogue work progressed. It included the Nara ehon of scrolls "Genji Text and Images" that Professor Tokue had come all the way to Dublin for. Also included were the venerable scrolls "Genji Text and Images" that would be restored at the Imperial Household Agency, "Picture Scrolls of the Tale of Muramatsu," and other precious items. This form proved that Chester Beatty had already gained possession of these items during the Taishō period, much earlier than the generally held view. Incredulously

I read and re-read this document until the library's closing bell rang, completely forgetting the cold winter night air that had crept into the building.

Since that moment of discovery I had been waiting for an opportunity to find out more about how Chester Beatty had come to purchase the items.

During the summer of 1988 while I was back in Japan to prepare for the "Homecoming Exhibition," I took a few extra days to visit Kyoto. The NHK crew and Mr Sakakibara were with me for the production of the TV programme. I was hoping to follow the same footsteps, at least some of them, that Chester Beatty had taken in 1917. Following Mr Sakakibara's advice, we retraced Chester Beatty's footsteps, although it was likely he would have travelled in the comfort of a rickshaw. Some of the traditional shop fronts bore English or Roman-lettered signage, suggesting that they might have welcomed quite a few foreigners in those days. Yatarō Okita had been a guide then, and had escorted foreigners through the antique-filled shops in these alleys of Kyoto. With his fluent English, he had looked after many foreigners staying at the Miyako Hotel, including Chester Beatty. He had kept up correspondence with Beatty through letters and telegrams even after he had left Japan.

The auction for the collection of Yoshitarō Okamura (a Nishijin textile manufacturer) had taken place in 1916 (Fifth year of Taishō). Its catalogue included "Scrolls of the Town and Country" (Tohi Zukan) by Gukei Sumiyoshi, one of the very items that was part of the "Homecoming Exhibition." In the catalogue for this auction held in the Kyoto Art Club, it was listed under a different title, "Kodai Fūzoku Zukan," and was shown as 'unsold' after the auction. In the following year, when he stayed in Kyoto, Chester Beatty had purchased this piece from an antiques dealer, Tōichirō Taniguchi. This had been described in the document attached to the export application form.

We tracked down the Taniguchi Store, which wasn't far away from the Art Club in Shin Monzen-machi town. It still bore the original English signage that Sir Chester would have seen. A young lady, the third-generation owner of the antique business, explained that her grandfather had had a good command of English, and that he had been quite enthusiastic to trade with foreigners. She thought it quite possible that he would have dealt with Chester Beatty, but could not be certain, as it had happened in the distant past.

Our next stop was a small elegant antique tea utensil shop, run by Mr Hayashi. He had started this business at the age of fifteen, and when I met him in 1988, Mr Hayashi was over eighty years old. He vaguely remembered the auction of the Okamura collection, to which he had been brought as an apprentice. He said that the unsold scroll would probably have been sold through the Taniguchi store to a foreigner with an interest in the genre paintings depicting life in old Kyoto.

Finally we visited Mr Torii, who lived in Konyamachi. He welcomed us into the formal Japanese room in the rear of his house. Dressed in a suit, he knelt, sitting on his heels bolt-upright. His elegance and eloquence gave him the appearance of a learned scholar. Looking so spry, he belied his ninety-three years, and still served as a director of the board for Nishijin Obi textile manufacturers. He spoke slowly with a clear and steady voice, punctuated with pauses. He recalled that there had been an apprentice called Okamura who had served with his uncle. Mr Okamura had gone into service at twenty years of age, and had studied "Mon-ori," patterned textiles. Mr Torii explained that Japanese textile-workers would have had an almost obligatory deep interest in old works of art. By studying old paintings and other art objects, craftsmen were inspired for new ideas and designs that reflected Kyoto traditions. In those pauses as he talked, the clatter of the textile looms echoed through the quaint old house with the garden shrubs glistening

wetly in the rain. As the evening closed in, it seemed to deepen the sense of Kyoto's refined elegance. I told Mr Torii to stay well, and then stepped out through the sliding lattice door. As I left, I could hear the drumbeats of the Gion Festival in the distance.

Chapter 18

Old Sumo Dolls

IN THE SPRING OF 1989 the picture scrolls and books exhibited at the "Ireland's Chester Beatty Collection: Tales of Japan" exhibition had been put back in place in the repository, and my life quietened down.

One day I received a phone call. It was the Belgian ambassador. He asked me if I could take a look at a Japanese ornament that he had. Consultation was one of a curator's jobs, so a few days later I took the ten-minute walk from the library to his residence. I was feeling a bit nervous, not sure what kind of item I would be asked to look at, and whether I would be able to carry out my task. I was ushered by a butler into the spacious living room. There was a large television by the window. On top of it was the ornament in question, with no protection whatsoever.

It was a pair of porcelain Sumo dolls, which grappled with each other as real wrestlers do in a match. There was no doubt that it was made in Japan. I remember how astonished I was, and a little tense as well. I put on my white gloves and asked the ambassador's wife whether the ornament was left on the television all the time. She nodded and explained that the ambassador's father had had a great interest in and knowledge about Japanese pottery and porcelain. The story went that he had purchased the piece when he had stayed in Japan. She added that he had been fond of Sumo wrestling. Perhaps it was that the ambassador was reminded of his father as he sat watching TV.

I had never seen an actual doll of this type outside of an exhibition catalogue. Nevertheless, my scanty knowledge and recollection told me that this might be an extremely rare and precious item. One of the wrestlers had a red-orange Obi belt, which suggested that it might be one of the "akae" ('aka' meaning red) porcelain items by the renowned artist Kakiemon. One of the school textbooks I had as a child had described a potter in Arita, a porcelain pottery town in the southwest of Japan. He had striven to produce "akae" (red glaze) for porcelain, and had spent a long time, trying different materials and combinations, until he finally succeeded in producing a glaze with a distinctive red-orange, the colour of kaki (persimmon). And now, a wonderful piece of that "akae" porcelain was sitting right in front of my eyes, on top of a television in the front room of the Belgian ambassador's residence.

I took various measurements of the dolls, from a variety of angles, as well as several notes. I told the ambassador's wife that I would need to consult with some experts before I could provide further information. Before leaving, I asked her to move the dolls somewhere safer, rather than on top of the television.

When I returned to the Chester Beatty Library, it was already dusk; the evening sun had just disappeared behind the city. It was practically time for me to head home, but I was excited. I rang Professor Impey of the Ashmolean Museum at Oxford University. He was a good friend and an authority of Oriental pottery and porcelain. I explained what I had seen that afternoon, and asked for advice. He rang off to check some facts but then, almost immediately, called back.

"It sounds like the dolls are a great gem of Kakiemon porcelain from the 1660s. To top that, it's very rare to have a pair of Sumo-wrestlers!" His excitement was infectious, and I set off home quite exalted.

Museum curators receive this kind of inquiry and request on a daily basis, but we are not allowed to set a valuation, let

alone giving help in selling or buying. Thus I relayed Professor Impey's marvellous comments to the ambassador.

After this episode I became busy again with other pressing work, and it slipped out of my mind, until I received a call from the ambassador.

"My retirement is coming up soon, and I'm going to leave Dublin shortly. As a matter of fact I would like to get rid of the pair of dolls while I'm here. I was wondering if you could help me, I would be happy to offer a generous reward for your service."

I was startled, and I explained that I could only help in the scope of a curator. I added that according to experts in the field it would be best to sell at auction in London. I managed to convince the ambassador and he decided to approach one of the auction houses there. Case closed, I thought; and what a valuable educational experience for me.

Shortly afterward Professor Impey called me, and asked whether the Chester Beatty Library might be interested in acquiring the sumo dolls. He was hoping that the dolls would stay in Europe if at all possible, and he had some funds that might help.

Despite his enthusiasm, and his offer, the straitened financial circumstances of the Chester Beatty Library did not allow us to scrape together any funds toward this.

In the following year, the ambassador told me that arrangements had been made to put the items up for auction in Sotheby's in early June. Some friends in London rang to tell me that the sumo dolls had made the cover of the auction catalogue, an indication that it was the prime article in the sale. I had already informed some Japanese curators who specialized in this area in Tokyo and Kobe. One of my friends in Christie's, who attended, gave me a detailed account of the auction. On auction day, the hall was crowded with more people than expected. There were the telephone bidders as well from all

over the world, including Japan. And it was a Japanese buyer who finally achieved the winning bid, with a sum substantially higher than expected, and this caused quite a stir in Oriental art circles for some time afterward.

I was relieved, out of consideration for the ambassador, that it had gone so well but also felt a tiny bit of regret as a curator in a library that housed these kinds of art objects. The precious item was on its journey back home to Japan, having spent over a century in Europe. What fate would await these dolls in the future? Someday perhaps these sumo wrestlers might make a re-appearance at some museum or gallery. I look forward to the opportunity of seeing them again.

Chapter 19

Teaching History of Japanese Culture at Trinity College

THE JET PROGRAMME (Japanese Exchange and Teaching programme) is promoted by the Japanese government with the aim of improving the English competence of Japanese students at primary and junior high schools. Through the Japan Foundation, college graduates who speak English as a mother tongue are selected and sent to Japan. Ireland has been in the programme since 1988, and a number of young Irish people have had the opportunity to travel to teach at schools in Japan, with considerable success, and have usually ended up being very popular with students and teachers.

The JET programme had actually been launched in Japan a year earlier in 1987, but had not included Ireland in the scheme. However, in the summer of 1987, a member of the NHK television production team was visiting the Chester Beatty Library for the preparations for the "Homecoming Exhibition" that was to take place in the following year. At the time, the library was located within a five-minute walk from the Japanese embassy, so I took the television producer there to pay a courtesy visit. At the embassy we talked to the press and cultural officer who, to our surprise, hadn't visited the Chester Beatty Library. So he let fly a shower of questions on what cultural activities the embassy had been involved in. The meeting became slightly awkward. After a while he started to quiz her about the JET programme, and the reasons the embassy hadn't launched the programme in a country famous

for speaking English so eloquently.

Maybe it was a coincidence, but Ireland duly joined the JET programme in the following year.

It was a welcome beginning for many people in Ireland. For me though, it was not so welcome, as I became involved in the screening of young Irish candidates. My curator workload was increasing and this further role added to the pressure. Twice a year I conducted interviews together with an Irish government official and some other examiners. I had to screen the applications as well, and this needed to be carried out within a very short space of time. Overall it was demanding, but I did accept that it was a very important task in the overall picture of building a bridge between Ireland and Japan.

The number of applicants varied from year to year, and depended on the economic circumstances in Ireland. At present over eleven hundred successful Irish candidates have travelled to Japan with the JET programme. When I was told of this by the embassy, I felt quite delighted and proud. More so when I heard that many of these went on to work with various Japanese government agencies or Japanese companies once they graduated from the programme.

Maybe partly triggered by these events, local interest in Japan suddenly began to grow, particularly at various colleges and universities in Ireland. This too had repercussions on my life. One day I got a call from Professor Louis Cullen from Trinity College Dublin. He said that he was about to launch a lecture series on Japan and needed help with the lectures. This was quite out of the blue, and took me quite by surprise. Trinity College, founded in 1592, had such a long and distinguished history that I felt quite honoured. But at the same time, I realized the heavy responsibility and time that this represented. Professor Cullen had been an old friend and I was very much aware of his deep interest in Japan. He frequently brought his students to the library. Although his main field was modern

and contemporary history, he had a deep fascination with the exchanges between Europe and Japan that had started much earlier. His request for me was to deliver a two-hour weekly lecture on the history of Japanese culture, using the Chester Beatty Collection. I asked him to give me a few days to think it over and hung up the phone. I first talked with the director of the library, Dr Michael Ryan, who was delighted with the request and pushed me to accept it.

The next day I accepted the offer on a one-year basis.

There were thirteen undergraduate students taking Professor Cullen's seminar course. For each class I had some twenty slides prepared, and talked through these in English. It was actually a very good experience for me. I talked about Japanese art and its historical and cultural backgrounds, and the students were more positive in their reaction than I had imagined. This calmed down my initial nerves, and before long I found myself looking forward to each session. This was in the autumn of 1989.

The course was meant for one year, but it continued until 1996 when I retired from the library. Dr Claire Pollard, my successor, took over the course, and it continued until Professor Cullen retired in 2002. Among the students, there were a couple of foreign students who were in the Erasmus Student Exchange Programme, and this helped to enrich the multicultural atmosphere in the class. At times I felt quite nonplussed by their enthusiasm. Some of the students had fairly good knowledge of Japanese and even spoke some phrases. I made it a custom that the class would visit the Chester Beatty Library once a month, and the students loved this. We were in the very lucky position of being able to use genuine articles such as ukiyo-e, picture scrolls, books, inrō, netsuke, and armour for our studies.

And to add to my good fortune, I could count on the staff at Trinity College to prepare the photographic slides used for my lectures. In addition, I found that the following reference books were very useful and informative for the class:

Sekai no naka no Nihon kaiga (Japanese Art in Perspective: A Global Review) by Ikuo Hirayama and Shūji Takashina, Bijutsu nenkansha, 1994.

Japan: The Shaping of Daimyo Culture, Edited by Yoshiaki Shimizu, Thames and Hudson, London, 1998.

Chapter 20

Mr Peter Morse and The Great Hokusai Exhibition

THE GREAT HOKUSAI EXHIBITION was held in 1993 to introduce the work of an outstanding Edo artist, Katsushika Hokusai. For this exhibition, his notable ukiyo-e and surimono prints were gathered from different parts of the world in his hometown of Tokyo. It was nearing the end of 1992 when I headed for Tokyo together with a selection of works from the Chester Beatty Collection. As Tokyo International Airport was temporarily closed due to unusually heavy snowstorms, my plane was forced to stand by in London for over five hours, and finally took off around midnight. In any case I had had a hectic schedule leading up to my travelling, so I managed to sleep through most of the flight. The plane finally touched down in Narita late at night. People working for the exhibition who had travelled to the airport to meet the delayed flight were there to greet me. There were some other curators arriving at around the same time from other museums, so together we had a late dinner on our way to Tokyo. Before heading for the hotel, we dropped by the warehouse to check for any damage during transit to the packages of woodblock prints. Specialized art transportation vehicles had brought them in from the airport, where the paperwork had been cleared. They would be brought onwards to the exhibition site on the following day. So it was nearly dawn by the time we checked in at the Hotel Fairmont in Tokyo. I collapsed, literally, in the bed in the room. Some hours later, I went down to have a very late breakfast. I only began to fully wake up as I had an

authentic Japanese breakfast, something I had not enjoyed for a long time. I recognized a foreign gentleman reading a newspaper over a coffee at the next table. He smiled and asked, "Are you here for the Hokusai Exhibition?" He was none other than Mr Peter Morse, whom I had met on several occasions over the years including the Paris Hokusai Exhibition held ten years earlier. He was an art historian and also a world-renowned Hokusai collector. In the breakfast room we had a good chat and renewed an old friendship. He smiled and said in his soft voice, "I'm happy that the Hokusai connection has brought us together again from distant parts of the globe."

The next days passed very quickly in the various preparations for the exhibition at the Tobu Museum of Art. In the various commuting journeys to and from the museum in Ikebukuro, I would share taxis with Peter and some of the other curators. The *Asahi Shimbun* newspaper was sponsoring the exhibition and Ms Mayumi Ono, who was in charge, was a good friend. When she asked, as a favour, that I might look after foreign curators staying at the hotel, I accepted without giving it any special thought. I had no idea how much trouble this would land me in some days later.

With the New Year approaching, the hotel had put up the traditional decorative pine and bamboo tree arrangement at the entrance, and this put me in a festive mood as I had missed this occasion for a long time. In the breakfast room there was a notice for a New Year's Day special festival meal that could be reserved, and it would include a complementary serving of otoso, a special spiced sake. I was quite looking forward to being present for the Japanese New Year celebrations for the first time in decades. Mr Morse conversed in his soft voice, complimenting the Chester Beatty surimono collection as well as the library's catalogue, "The Art of Surimono," that had been authored by Roger Keyes. He said he was particularly looking forward to viewing the Chester Beatty surimono prints at the

exhibition. While chatting, I happened to notice a little open seam on the shoulder of his jacket. As I had a small sewing kit in my bag, I mended it quickly on the spot. Mr Morse, who had no interest in clothing, said "Thank you" in his quiet voice.

After breakfast, a car that the museum had arranged picked us up and we drove to the Tobu Museum of Art through the big city decked out for the New Year celebrations. The preparations for the exhibition were nearing completion, and we spent the day doing final checks on the captions and other last minute tasks. Back at the hotel that evening, some friends from different museums awaited my return, and we had an enjoyable time over dinner catching up with each other. In the corner of the restaurant, Mr Morse sat on his own, having a light dinner while reading a book. After a little while, he came over to say good night to me before heading out of the dining room. Who could have imagined that it would be the last time I saw Mr Morse?

Early the next morning I received a phone call from the receptionist, who broke the news to me that Mr Morse had passed away during the night. I was completely shocked. Having no time for breakfast, I went down to the lobby. It was only when the other people who I knew were working on the exhibition arrived one by one, that the news gradually sank in. A doctor was called, and he presumed that the cause of death was a heart attack. Mr Morse's body was brought through the rear of the hotel to a nearby hospital for an autopsy. A death, during the night, alone, in a foreign hotel room: this fact made each of us pause for thought as we gathered in the lobby. In the midst of that sorrowful atmosphere in the lobby, I was ordered by the police not to leave the hotel as I was regarded as a witness. It was shocking enough to be met with Mr Morse's death, but it was quite something to be told effectively that I was being detained as a "witness." I was very puzzled and a bit nervous. I realized that our rooms had been opposite each other in the corridor,

and that we had spent a bit of time together. It wasn't difficult to guess the questions that the police would have, so my anxiety rose. Hours passed until I finally found myself sitting in front of a detective. He had obviously obtained a little information already, including the fact that Mr Morse's room had not been locked. He had also been informed that Mr Morse had said good night to me in the restaurant, and that these had been effectively his last words.

The police confirmed that Mr Morse was a diabetic and that they had found his syringes for injecting insulin. Other questions were explained reasonably. Mr Morse and I had been chatting with each other and sharing lifts on the basis that we were old friends and were working on the same exhibition. Everything had a satisfactory explanation. I understood that the police had had to conduct the investigation and interview me. It was after three o'clock when I was finally released and allowed to leave the hotel. The whole experience made a lasting impression on me, on top of the sorrow I had for losing a friend.

Mr Morse had been in Japan to exhibit his world-renowned Hokusai collection at the Tobu Museum of Arts as well as two other museums. He had written a paper, "Hokusai's global reputation," for the Great Hokusai Exhibition catalogue. It was the last paper he produced. The catalogue still sits on my bookshelf.

Mr Morse was one of the descendants of Edward S. Morse, famous for his discovery of the prehistoric Ōmori Shell Mound in the west of Tokyo. Although a zoologist, Edward too had had a great interest in ukiyo-e prints in his early years. He had been hired by the Meiji government, and among the tasks he carried out, he implemented successful institutional reforms at Tokyo Imperial University. Interestingly he privately produced an English paper, entitled "Note on Hokusai, the Founder of the Modern Japanese School of Drawing," in 1877.

Peter's Hokusai collection is now housed and cared for

at the Sumida Hokusai Museum in Tokyo, which opened in November 2016. This site was chosen to meet the request from his family, who wished to avoid the collection being scattered. This goal was realized through the efforts of many people, including Professor Seiji Nagata.

Chapter 21

The Chequered History of "The Chōgonka Scroll"

"THE CHŌGONKA SCROLL" (Chōgonka Zukan) was painted during the seventeenth century by Kano Sansetsu in Japan. It illustrates a Chinese narrative poem, written by Bai Juyi in the early ninth century in the old capital of China during the Tang dynasty. It travelled a huge distance in space and time, ending up in twentieth-century Ireland. It depicts a famous Chinese legend of the tragic love between Xuanzong, the sixth Emperor of the Tang Dynasty, and Yang Guifei, a lady of peerless beauty. The scroll beautifully visualizes the world of Bai Juyi's poem, "The Song of Everlasting Sorrow" (Chōgonka in Japanese). It was quoted in *The Tale of Genji* in several places, and is even now one of the most beloved works of Chinese poetry.

> This Chinese emperor, loving beauty, longed for the 'killer of Empires.'
> Yet for many years of his reign he could never find one.
> There was in the family of Yang a young girl grown to womanhood,
> Reared in the inner apartments and scarcely known . . .
> Translated by Arthur Waley

In September 1978, I was enjoying a moment of relief after seeing through to a successful conclusion of the International Research Conference on Illustrated Japanese Literary Texts, when I received an unexpected visitor from Japan. Without a prior appointment, he just showed up at the library, seemingly

well aware of the conference, which had come to an end just a few days earlier. His name was Hisao Kawaguchi, and he was an honorary professor at Kanazawa University. The first thing he asked, having travelled from Japan to Dublin, was "Are there any pieces that weren't studied during the conference last week? I would very much like to see them." This request took me somewhat by surprise. He scrutinized the catalogue that had been prepared for the exhibition, and spotted the Chōgonka Scroll excitedly, saying "No one seems to have studied this, please show it to me!" He explained that he had been searching for the Chōgonka Scroll for a long time, had dreamed of finding it, but had never seen one in China or in Japan. He was clearly very excited.

Professor Kawaguchi was a famous researcher on Chinese literature. I remember he told me about his visits to Dunhuang and Xian (old name Chang'an: the capital of the Tang Dynasty). To meet his request, I needed to get permission from the library director, who gave him two days to study the material. As it was immediately after the big conference, the library was short-staffed, especially with fewer security guards on site than usual. So it was not possible to permit a longer duration.

The professor lost no time and started to handle the scrolls with such joy and excitement that I had to remind him to unwind them slowly and gently.

The Chōgonka Scroll consists of two scrolls painted on silk, each being 31.5 centimetres in height, and around 10.5 metres long. They are very long scrolls, and every part of the scrolls is beautifully painted. When I first saw them, I had found them placed, without any special care, in a box of paulownia wood, which was reddish brown.

The professor, overjoyed at the stunning painting of the scrolls, pleaded and demanded that his time be extended as he wished to study the scrolls in more detail. I approached the director timorously with this request, and managed to gain an

extension for another ten days on condition that I personally supervised him daily.

Professor Kawaguchi resumed his research, taking photographs of each scene on the scrolls with the camera he had brought from Japan. Permission for this was granted on condition that the photographs be used solely for reference purposes. Yet his treatment of the scrolls seemed to me to be most unlike that of other experts on Japanese art history whom I had assisted. I had to raise my guard and I kept him under a constant and close observation.

Four years later in 1982, Professor Kawaguchi published a book, *Picture Scrolls of the Chōgonka*, with Taisyūkan Publishing. To my great disappointment, he had broken his promise and used the photographs in his book, depicting every single scene of the Chester Beatty Library scrolls. I later received a courteous letter from him, asking for *ex post facto* approval. I translated the letter and reported the matter to the director and the board of trustees. I was devastated. I remember an English researcher consoling me and saying that some researchers were not above doing this kind of thing.

Yet, despite the unpleasantness that I had felt about this experience, Professor Kawaguchi's visit did set in motion a rather remarkable train of events, as I'll proceed to relate. In previous chapters, I've written about the work I had carried out to help compile the Sorimachi Catalogue. Impressed and inspired by Mr Sorimachi's determination, I had spent days and nights on the project. While working with the highly respected, benevolent expert, I had learned a great deal from an academic perspective, as well as about a philosophy of life. With the Sorimachi catalogue published and distributed to all of the conference participants, the library had been able to take its first step to put its name on the world map. It had been pure joy.

However, there were some parts of the catalogue that I had felt were not fully convincing. One of these related to the

Chōgonka Scroll. When I was helping Professor Kawaguchi with his examination of the scrolls, I noted that he held quite a different view about its authenticity from Mr Sorimachi, who had had to work hastily to complete the catalogue in time. This thorny discrepancy of opinion on the authenticity of the scrolls stayed in my mind for a long while.

Professor Kawaguchi recounts in the preface of his book that "They kindly showed me the precious piece in their collection, and, in fact, it was not yet fully analysed and documented. The piece, which has not been found anywhere else, includes all the scenes from the poem of the 'Song of Everlasting Sorrow' visualized in painting. I was beside myself as I took photographs with the permission of the director, Dr Henchy, and the assistance of Mrs Ushioda. This was a complete version of the precious scrolls, of which records had existed but the whereabouts had been unknown."

Mr Sorimachi, on the other hand, believed that this set of scrolls was a Chinese copy, done by a later painter, and that the Kano Sansetsu seal was not trustworthy. To try to resolve this discrepancy of opinion, I decided to pursue this issue and see if I could determine the truth somehow.

I started by studying the writings of researchers and scholars who specialized in the paintings of the Kano School. I read whatever papers and essays from the experts that I could get hold of in Dublin. These included writings by Professor Satoru Sakakibara, Professor Atsushi Wakisaka, and Professor Nobuo Tsuji. And whenever I returned to Japan on visits afterward, I made time to study Kano School paintings and visit any experts to gain further understanding. It was five or six years after I had started this when Professor Wakisaka came to the Chester Beatty Library after he had finished some business in London. He undertook a careful examination of the Chōgonka Scroll with the deliberate aim of ascertaining its veracity.

Several years later, in 1990, the professor published an article, "A study of Picture Scrolls of Chōgonka," in *Japanese*

Art and Crafts. He concluded, based on its style, that the Chōgonka Scroll was, without doubt, the work of the Kano School. This raised a further question as to whether Kano Sansetsu had painted more than one set of the Chōgonka Scroll. It is because another version exists, attributed to Kano Sansetsu. This other version is slightly smaller, painted in light colours on paper, and is mentioned in the 1893 issue of *Kokka*, a respected Japanese art periodical. It bears the Sansetsu seal, which is proportionately smaller with letters in a cursive style. It bears the signature of Kano Hōkyō, just to the right of the seal. Hōkyō is a title of the highest recognition, which Sansetsu received in the Tōfukuji Temple in 1647, a year after the date inscription of the scrolls. This means that the signature must have been added afterward. This version had been held in the Kuki Family collection until 1988, and had not been viewable by the public. It was rediscovered in recent years, and is now housed in the Suntory Museum. It had long been held that the Kuki version was an original and the Chester Beatty Library version a copy. But a number of researchers, including Professor Wakisaka, overturned this view and concluded that the Chester Beatty Library version could not be a copy, as the quality of the painting and the materials used, including the silk support, were excellent. In addition, the Chester Beatty version used a special technique called verso painting (ura-zaishiki), where the work is painted on the back in reverse. Although there are still some questions and areas for study in the future, what can be said at present is that the Chester Beatty version is the only "silk" version of the Chōgonka Scroll that exists today.

So while we arrived at this conclusion after much study, there was another issue with the Chōgonka Scroll; the condition of the scrolls was so poor that rolling and unrolling them was very difficult without causing further damage. Their fragility meant that they could not even be used by researchers, let alone for

exhibition. In the hope of getting some aid for the restoration of the scrolls, I approached the Japan Foundation again. And following a few years of waiting, I received great news, and the restoration project finally got moving. It took place as part of the "Japan Art Restoration Project" which was set up for Japanese artwork residing outside of Japan.

Back in 1979, as we worked on the Sorimachi Catalogue, we had listed items requiring restoration in order of urgency. This list, which had been submitted to the board of trustees, proved to be useful. Most of the items in the list were picture scrolls, and these could only be restored in Japan. Then, a restoration expert sent by the Japan Foundation arrived at the library with his assistant. Mr Tatsuji Handa ran restoration studios, Handa Kyuseido, including a studio in the Tokyo National Museum. During his two-week stay, he and his assistant conducted an initial survey and carried out as much restoration as they could on site in Dublin. For a few items that could only be properly restored in Japan, they provided some temporary treatment. This included the Chōgonka Scroll. Mr Handa sent a recommendation letter, stating that some of the library's items would require full-scale restoration in Japan, and that the work needed to be carried out as soon as possible. As a result of this, two items from the collection were selected for inclusion in a larger-scale project called "Restoration of Japanese Art in European and American Collections." The project was led by Professor Ikuo Hirayama, one of the foremost Japanese painters in the late twentieth century as well as President of Tokyo University of the Arts. He was also an active philanthropist as a Hiroshima survivor. The project was run by various agencies and organizations in Japan, including Tokyo University of the Arts, Tokyo National Research Institute for Cultural Properties, and Tokyo National Museum. Given that there were many worthy art objects throughout the world in need of specialist restoration, we were very fortunate to have two items chosen.

After a period of planning and preparation, the Chōgonka Scroll would finally make its first homecoming in 1994.

Toward the end of February in that year, I had finished the necessary paperwork and transport arrangements, and boarded the jetliner on the twenty-eighth with the Chōgonka Scroll in a specially constructed suitcase. I had to be very careful to protect against any possible incident that might cause damage to the fragile treasure during the flight. After transfers and long hours, the plane touched down at Tokyo International Airport.

In Tokyo, the restoration didn't get started straightaway, contrary to my expectation. There were several meetings held where experts from the various institutes examined the scrolls and discussed all the possible issues and solutions, each fully respecting the others' different perspectives. I was deeply heartened by the overall feeling of cautious enthusiasm that developed over this period of time. Finally, the restoration work began at a studio in the Tokyo National Museum.

Before describing the restoration work, I would like to explain how the Chōgonka Scroll had made its way to the Chester Beatty Collection after its disappearance and rediscovery. Before Chester Beatty purchased it, Louis Gonse had owned the scrolls. The vermillion seal stamped on the title slip attached to each scroll clearly shows his ownership. Louis Gonse was the chief editor of a French magazine, and a collector of Oriental art objects. A number of fine objects originally owned by him have been found in European and US collections. Louis Gonse had tried to sell the Chōgonka Scroll on two different occasions. This was confirmed in an auction catalogue kept at the residence of his nephew, François. I discussed this with Professor Matthi Forrer, a Japanese art expert at Leiden University, when he visited the Chester Beatty Library. The professor called me when he returned to the Netherlands and told me that the scrolls had not sold at the second auction

either, according to some annotations in the same catalogue
he found at the university library. This made sense to me, as
I was well aware of the poor condition of the scrolls. When I
had rediscovered them at the library, they were in an appalling
state; the silk support was torn and had become threadbare in
some parts. During Professor Kawaguchi's visit we had had to
be extremely careful in our handling to prevent more damage.
I wondered why Chester Beatty would have chosen to acquire
the scrolls in such condition.

He hadn't purchased them during his stay in Japan in 1917.
Some records suggested that he had bought them from an art
dealer in London in 1954, after he moved to Dublin. As I've
written earlier, Chester Beatty had purchased a large number of
ukiyo-e prints, mainly through Mr J. Hillier, an English expert,
in the 1950s and afterward. It's understandable that these
purchases could have included picture scrolls. Every item in this
tranche was acquired in the markets in Europe. According to
his memoir, Chester Beatty had requested Mr Hillier to make
substantial purchases including woodblock prints to add to his
Japanese collection as it had been eclipsed in size by his Islamic
collection.

When I started to work at the Chester Beatty Library in
the early 1970s, the generally held view was that all of the
Japanese items had been acquired in the1950s and later, with
the exception of decorative artworks such as inrō, netsuke, and
sword guards. These had been purchased in New York through
the Yamanaka Company. Through a set of discoveries analysing
his old files over the years, I had corrected this view. One file I
found during my very early years, even before the Nara Ehon
Conference, was a detailed record of his purchases during a four-
month stay in Japan in 1917. It included some photographs
taken during a welcome reception held for the Beatty family
by the Yamanaka Company in Osaka when he had travelled by
rickshaw through the city.

In the same file, there were letters and telegrams that Chester Beatty had exchanged with Yatarō Okita from Nara. Mr Okita had been an interpreter cum assistant for Chester Beatty. After he returned to the US Mr Okita continued to help Chester Beatty with acquisitions. In a letter from Mr Okita in April 1918, I found that Chester Beatty had purchased one of the miniature "One Million Pagodas" (Hyakumantō) with a printed invocation (Darani) inside. As these printed invocations are amongst the oldest known in the world, dated circa eighth century, the pagoda and invocation must have fascinated Chester Beatty. He had already acquired written treasures of historical importance from other ancient world civilizations, such as papyruses from Egypt and tablets from Babylon.

After finding the file, my next task was to locate the actual miniature pagoda. As expected, it was stored in a box for Chinese objects together with other Buddhist scrolls, sutras, and similar items. It also contained many precious Japanese sutras, including a "Chūson-ji Gold Silver Sutra" with alternating lines written in gold and silver against a dark blue background. This sutra had reportedly been presented to the Chūson-ji Temple during the late eighth-century Heian period. Besides sutras, a reddish brown box caught my eye; the words "Gogokudono Kurohonzon engi emaki" were written in brush with black ink. I imagined it might contain a Japanese picture, or perhaps some hanging scrolls, as it was with other Japanese items. I cautiously opened the box.

I was astonished. A set of two picture scrolls was revealed. A white title slip was attached to each scroll, and marked with "Chōgonka zu 1" and "Chōgonka zu 2" in black ink. And each slip had Mr Gonse's vermillion seal stamped. The original box must have been lost some time in the past, so the scrolls had been placed in a box bearing a different title. Hardly believing they might actually be genuine, I got permission to examine them from Ms Chapman, my boss and the curator of Oriental

Arts, and then I cautiously took the scrolls out of the box. As Chōgonka (The Song of Everlasting Sorrow) is a narrative poem composed by the renowned Chinese poet, Bai Juyi, it was perhaps not surprising that the scrolls had been stored as a Chinese item. Nevertheless I was hoping in the back of my mind that a Japanese artist had painted them as the poem was loved by so many in Japan, and was a favourite of Chinese poetry-lovers. The poem was known to have greatly influenced the Japanese Heian literature movement. Together with Jan Chapman, I unrolled the scroll slowly, uncovering miniature paintings depicting the famous Chinese legend of tragic love between the Emperor Xuanzong and his concubine Yang Guifei, renowned for her beauty. The damage was severe; the silk support was torn and had become threadbare in places. We progressed very carefully to view each painted scene, so it took a long time to reach the end of the second scroll, and I could not believe my eyes. There, at the end, was the signature and seal of Kano Sansetsu, a Japanese artist. The poem by Bai Juyi was not included, but it was easy to follow the story of the doomed love affair from the detailed paintings with their strong colour toning on silk cloth. Indeed, the poem was so famous at the time that it was on the lips of so many people, and there might not have been a need to include it.

After this, we reclassified and moved the Chōgonka Scroll to the Japanese collection. It was included in the list for the International Conference of Nara Ehon held in 1978. And it had stayed in the box until Professor Kawaguchi turned up in Dublin and asked to view it.

So it was that in the spring of 1994, the Chōgonka Scroll was back in Japan for restoration work to be carried out in the Handa Kyuseido studio in the Tokyo National Museum. After the thorough initial examination and discussion, a precise plan was made for the restoration. I was in the studios

with Mr Seiji Handa as the restorers started to dismantle the scrolls. I was impressed with their absolute concentration and precise surgeon-like movements of the hands as they worked. Several times I went back to the studio and learned from the restorers about the verso painting technique (ura-zaishiki). It was a very rare technique. They explained that the use of this technique could only be confirmed by dismantling the scroll as the restoration process required. The restorers actually felt very lucky to be able to witness and examine a piece that used this precious technique. Verso painting originated in China and had been used in Japan as well to create complex colour effects by painting from the front and back. It allowed strong colours to be toned and graduated, as well as adding subtlety to the muter colours. In the Chōgonka Scroll, in the scenes where Xuanzong and Yang Guifei were enjoying life and luxury, the technique is used to enhance the brightness and brilliance of the painting. Where their lives become tragic, the technique emphasizes the darkness of the scenes. The restorers explained that the plain weave silk support allowed the artist to make use of both sides for paint, something that was not possible with other kinds of support, such as paper. The open weave of the silk support enabled the colours painted on the reverse to combine with the pigments on the front. It was this that allowed the creation of complex colour-blending effects. The restoration progressed painstakingly, and slowly. It required that the very thin Washi paper lining be peeled with utmost care. During the process, the restorers could analyse how the various paints had been used. It is said that this technique originated in China and had been used for many of the Buddhist paintings. Ito Jakuchu, an extraordinary Japanese master painter in the mid Edo period, had used the verso painting technique as well. But there were hardly any other paintings other than the Chōgonka Scroll where the technique was used in such a detailed and brilliant manner. With the undoubted artistry of the work,

the authenticity of the scrolls was clarified and established the item as one of the most precious treasures in the entire Chester Beatty Library collection.

All through his life, Sir Chester Beatty persisted with his motto, "Quality over quantity, quality, always quality!" He always respected the experts' views, as he knew he was an amateur in the art world. But it led to the formation of the outstanding Chester Beatty collection, and the Chōgonka Scroll stands as an eloquent witness to his principles.

Chapter 22

A Route to Rebirth of Masterpieces

The "Rebirth of Masterpieces: The Japan Art Restoration Project" exhibition was held in May 1995 at the Tokyo National Museum. It was one of the fruits of labour of Professor Ikuo Hirayama, a great philanthropist who had striven for world peace through a range of cultural activities. The conservation and restoration of Japanese cultural assets abroad was just one of these activities.

Professor Hirayama passed away in 2009. In his obituary, "Mourning for Professor Ikuo Hirayama," published in the *Nikkei Newspaper* in December 2009, Mr Toshio Tabuchi, a master artist, wrote:

> Together with Professor Ikuo Hirayama, I had the opportunity to visit a Japanese lady who worked alone in a library in Dublin, Ireland to care for Japanese cultural assets. It is an obscure [sic.] library, which few Japanese researchers know about. He exclaimed to me with enthusiasm, "Japanese cultural assets abroad, no matter how small, are ambassadors for Japanese culture. That's why looking after them will help lead to world peace.

This first visit by Professor Hirayama would bring him to visit the library again, this time accompanied by a delegation comprising researchers from the National Research Institute for Cultural Properties and experts on Japanese paintings. But none

of this would have happened had it not been for the blessing of the Emperor and Empress of Japan.

I would like to go back to an episode from 1985, when the Crown Prince and Crown Princess (now Emperor and Empress) paid their first state visit to Ireland. It was an official visit with the schedule detailed down to the minute, but the Imperial couple made it known that they wished to visit the Chester Beatty Library. This surprised many people, including government officials. As soon as I had received word from the Imperial Household Agency of this request, I decided to set up a special small exhibition for the occasion. From the library's wide Japanese collection, I tried to evoke the atmosphere of the Edo period, with the collection's unique world-renowned surimono prints. As I started to prepare and select the items for display, it occurred to me that the exhibits would include many items depicting the pleasure quarters and the colourful life of its courtesans. I felt it would be prudent to make an enquiry to the Imperial Household Agency. Their response was, "Please proceed as you planned. They wish to see the very best, whatever it might be."

Here I digress to explain a little about the surimono collection. Three years earlier, the *Asahi Shimbun* newspaper of March 21, 1982 had printed an article introducing the Chester Beatty Library collection of surimono prints. The article explained that the genre was drawing attention as a hybrid of Edo literature and art. Professor Jūzo Suzuki, whom I came to know through the Asahi journalist when he visited, explained that this was an exclusive category of woodprints. Surimonos were privately commissioned works, intended to be distributed to a small audience of friends, colleagues, or like-minded members of a group such as a Kyōka-ren, or poetry circle. They were also used for occasions, for instance, when Kabuki actors announced their newly succeeded stage names. Since they were not sold to a commercial audience, the print

runs were very small; as a result very few have survived. Wealthy individuals commissioned them, so the level of workmanship was excellent. The most usual style of surimono included an image and verse of poetry. The Chester Beatty collection has some very rare surimono, jointly created by Hokusai and Santō Kyōden, a writer of the sharebon (gay-quarter novelette) genre. The surimono collection has been exhibited in Japan, France, and the US, and has attracted a lot of attention. When the Crown Prince and Princess viewed the collection, they showed particular interest in a large-sized surimono print; this piece had been distributed to members of Yotsuya-ren, a poetry circle of the Kyōka genre, led by Kisshū Karagoromo. This is the only remaining masterpiece of its size anywhere. Hokusai depicted a group of high-class courtesans in the pleasure quarters, and Kyōden had added the calligraphy of kyōka verse, which interplayed the links between the visual image and verbal verse.

Standing in front of this surimono print, the Imperial couple were very impressed. Delighted, they commented, "We have never seen surimono prints before. It is a rare thing indeed." Earlier, even in the minutes before the Imperial couple had arrived at the library, there had been a last-minute drama. As we were waiting anxiously for the couple to arrive, there was an emergency phone call from the Japanese ambassador. He told me that I was to use English instead of Japanese when I described the collection to the visiting party. This was for protocol reasons, as the delegates included Irish government officials, among them the Minister for Foreign Affairs. This was something that I had thought might happen, so I had made some arrangements. I had prepared an English draft of my presentation and handed this to Father Doyle, a close friend of mine (and a fluent speaker of Japanese), who also happened to be an acquaintance of the Imperial couple. Fortunately for us, he was back in Ireland during the spring break from Sophia University in Japan where he worked. I had asked Father Doyle to join the reception

team in the Chester Beatty Library. Almost immediately after taking this phone call, the Imperial couple arrived, the director delivered the welcome speech, and I presented a bouquet of flowers to the Crown Princess. The formalities, including the signing of the visitor register, proceeded smoothly. Then it was my turn to present. First I talked about Sir Chester Beatty and the history of the collection, and then moved on to presenting the selected exhibits. The Imperial couple had requested a viewing of the renowned "Picture Scrolls of the *Tale of Genji*," so I took one of the large scrolls out of the box and started to describe it in English. As I did so, the Crown Prince quietly said, "Mrs Ushioda, when it comes to the *Tale of Genji*, we would really like to hear it in Japanese." I had no choice other than to follow his request. I signalled to Father Doyle with my eye, and switched to Japanese. I could see that Father Doyle moved quietly but swiftly to stand behind the Minister for Foreign Affairs and his wife, and proceeded to read from the English draft in a whisper. I don't think anyone but Father Doyle and I knew how tense we were at that moment. Even now, when Father Doyle and I get together, we enjoy talking about this little secret.

This collection's *Tale of Genji* consists of four picture scrolls encased in a box labelled "Genji Text and Images" (Genji Kotoba-e), brushed in black ink. Twenty-seven court nobles, ranking from high to low rank, had done the calligraphy for the legends accompanying the images. Each nobleman had done two, the scrolls comprising fifty-four chapters in total. This rare set of scrolls did not fail to impress the Crown Prince. He was particularly interested in the "Genji Mokuroku," an attached list recording the name and rank of each court noble. While reading through the list, he checked each calligrapher and noted familiar names with the Crown Princess. I began to relax a little, as I watched the Imperial couple clearly enjoying the moment, tracing connections with the calligraphers. I continued with my

presentation, "Some experts believe that this high standard of work was produced by commission at an unusual setting. But it's conceivable that it came onto the art market, but with a high price. As for the painting style, it is perhaps in the Kano School . . ." I must admit that when I had first heard the Imperial Couple's request to view this set of scrolls, my heart had sunk a little. The paper used for the legends was so severely damaged that I had been afraid it might not be a suitable item to display at such an honourable occasion.

After the Imperial couple left Ireland, I replaced the picture scrolls back into their box. Given their condition, it occurred to me that the box might not be opened again for a long time. Who might have imagined that things would turn out so differently?

Some days later, I received a phone call from the Imperial Household Agency. The gentleman first expressed his gratitude for the kindness extended to the couple during their visit to the Chester Beatty Library and then continued, "We would like to restore those four scrolls of 'Genji Text and Images' at our restoration department, so please would you bring them to Tokyo at your earliest convenience." It was too good to be true! The next few weeks were unbelievably hectic and exciting, preparing the papers, and travel arrangements to bring the scrolls to Japan. Travelling with the precious scrolls was a heavy responsibility to carry, but with the support of so many people around me, it all happened smoothly. I'm deeply grateful even now at how fortune played out.

And so, returning to 1994, just before the opening of the exhibition "Rebirth of Masterpieces," I had the opportunity to visit Professor Ikuo Hirayama one Sunday afternoon at his home in Kamakura, a beautiful historic town on the coast. He recounted many stories, including his visits to Dublin. He explained that his first visit had been triggered by something that the Emperor and Empress had said to him. "There is a

small Oriental art museum in Dublin. When you have the opportunity, please visit it. There is a Japanese lady there who is working very hard, by herself." Professor Hirayama confessed that he had never heard of the Chester Beatty Library until that moment.

It did not take long before he found an opportunity to visit. When he had some business in London, Professor Hirayama made the crossing to Dublin. At the library, he was deeply impressed by the collection of Japanese paintings, and it was at that moment that he made the remark: "Japanese cultural assets abroad, no matter how small, are ambassadors for Japanese culture. That's why looking after them will help lead to world peace." This determination to care for such assets evolved into the Japanese Art Restoration Project, enabled with the support of the Agency for Cultural Affairs. And it finally blossomed into the "Rebirth of Masterpieces" exhibition. This is how the Chōgonka Scroll had come to be included in the project. When Professor Hirayama recounted this story, I finally saw with clarity the long path that had brought me to this point and that had seemed so murky for such a length of time. I was filled with a sense of deep gratitude.

Chapter 23

Filming 'Beyond Time and Space'

ONE DAY, IN THE early summer of 1993, I received an enquiry out of the blue from a friend in Dublin, Ms Yoshi Ishii, who had been actively involved in promoting cultural and economic exchange between Ireland and Japan. She mentioned that a director of the NTV (Nippon Television Network) had contacted her recently and told her that he was interested in making a TV programme to portray my life, both the public and private aspects. Ms Ishii covered a wide variety of work, including translation, tour management, and guiding, so I presumed that she was being asked to act as a go-between for this television project.

I had only three years left at the Chester Beatty Library before I was due to retire. Nevertheless, as I progressed with my work, I knew that there was an ever-increasing list of tasks that I wanted to complete. Every day I was swamped with a mountain of jobs, such as preparing for upcoming exhibitions in Japan, making arrangements for the restoration project, planning the exhibition of the Chōgonka Scroll on its return to the library, and so on.

Thus it was with some reluctance that I responded to Ms Ishii's inquiry and agreed to meet the director of the TV project to see what they wanted.

A few days later, the director, a producer, and some technicians travelled to Ireland and arrived at our home in Dublin. Over the next few hours they outlined what their plans were, and then they tried to persuade me, very persistently, to agree to the

project. Every question I raised was answered positively, and all the difficulties and inconveniences I foresaw were addressed. Finally I told them that they would still need formal approval from the director of the library.

Ultimately, one of the reasons that I was in the mood to accept was that I could not think of a better medium which would last through the years and I hoped that as many people in Japan as possible would come to know of the Chester Beatty collections once the programme aired. This anticipation continued to grow as the TV director discussed the matter, and finally it pushed me to accept. And I do think that the programme achieved the impact I had hoped.

Once filming started, the TV crew followed me almost everywhere, in my house, in the library, and in between on the DART commuter train service as I journeyed to work. They even included an interview with my doctor about the surgery I underwent as well as weekend scenes in the supermarket doing the grocery shopping, an activity I actually enjoy. And the filming continued in Japan as well.

In the completed programme the focus shifts from scenes of my daily life to the major project of restoring the Chōgonka Scroll. After the programme was broadcast, I heard that it impressed many in the art and academic circles as well as the general public. As I've written already, I had brought the damaged Chōgonka Scroll masterpiece to Tokyo University of the Arts for the initial inspection. This was in April 1994. Inside one of the rooms, several specialists led by Professor Hirayama as well as experts from other institutions gathered around the piece. They made a detailed inspection and then there was a full and enthusiastic exchange of views on how best to restore the scrolls to their former glory. Mr Tatsuji Handa from the restoration studio was also there, making very thorough notes.

I sat in a corner of the room and observed the inspection progressing, excited and tense, as these first-rate experts

discussed with the utmost seriousness the very piece to which I had devoted so much care and time. This was a moving and very gratifying moment for me.

The TV cameras recorded this as well as the whole process of restoration that took place at the Handa Kyuseido studio, from the dismantling of the fragile scrolls through to the very end when the scrolls finally were made beautiful and complete again. As the expert professionals proceeded with utmost care and precision to perform their delicate work, the TV crew worked with equal dedication and seriousness to record the entire process.

I felt the tension in the air and was caught up in it. My hands were trembling a little as I tried to take note of some of the technical terms that Mr Handa kindly whispered to me from time to time. Every time I watch this scene in the video, I can recall how tense things were in that studio.

The TV programme featured the exhibition of another set of picture scrolls, "The Tale of Muramatsu" (Image by Matabē). The Hiroshima Oshajo Museum (now Umi-Mori Art Museum) held a special exhibition of these scrolls in late September in the same year, and three scrolls belonging to the Chester Beatty Library were exhibited. It was a unique occasion where twelve scrolls owned by the Oshajo Museum were exhibited alongside the three from the Chester Beatty collection.

The record shows that Sir Chester Beatty acquired the three scrolls in 1917 in Nara. They were unusual and rare because colourful painting made up a large part of each scroll, leaving little space for the legend. I presumed this was the reason that Sir Chester purchased them, even though they were an incomplete set, as a complete set would comprise sixteen scrolls. Half a century later, on the publication of the Sorimachi catalogue, the revelation that a small library in a small country on the western seaboard of Europe owned three such scrolls caused a stir in Oriental art academic circles. Since then, whenever I travelled to Japan, I would bring a set of photographs of the scrolls, in

the hope of locating the remaining scrolls in that set. It wasn't an easy task, and when I had almost lost hope, I received word from Mr Masayuki Fujiura, a curator at the MOA Museum in Japan, that twelve scrolls of the "Tale of Muramatsu" had come onto the market. The MOA Museum had many works by the same artist, and Mr Fujiura was an expert on the subject. In due course he informed me that the Oshajo Museum in Hiroshima had made the winning bid for the twelve scrolls.

These scrolls bore a strong resemblance to those in the Chester Beatty collection, both in the painting style and in the calligraphy in the legend. However the number of scrolls, twelve, posed a little question. A complete set would comprise sixteen scrolls, and so one was missing. Various conflicting theories, assumptions, and guesses were expressed by different researchers, and a special exhibition was planned in Hiroshima with the aim of gathering the existing scrolls in one place as a start.

In preparation I travelled back to Dublin together with a curator from the Oshajo Museum. We completed the necessary administrative and technical preparations and then returned to Japan with the scrolls, heading straight onward to Hiroshima. The new Kansai International Airport had just opened in Osaka, and a crew from Hiroshima Television filmed our arrival and followed our journey. On the thirtieth of September, the "Tale of Muramatsu" exhibition was formally opened. For the ceremony, the Irish ambassador to Japan, Mr Sharkey, travelled from Tokyo, and delivered one of the opening speeches. The NTV director was also in attendance.

A research conference was held as part of the exhibition schedule. Unfortunately my own hectic schedule didn't allow me to participate, so I travelled back to Tokyo the day after the opening ceremony. I heard subsequently that the discussions had been very interesting and had stretched to the speculation that there might be more than one scroll in the set yet to be discovered.

For the first time in weeks I went back to the Handa Kyuseido studio to check on progress of the restoration work. When I saw what had been accomplished, I was completely lost for words! The restoration of the Chōgonka Scroll was so superb that I could now imagine how it had looked when first produced hundreds of years ago. The experts explained the various procedures and processes that they had undertaken and we watched the video that recorded the progress. In that very moment, I remembered just how nervous and fearful I had been when I had first unrolled the damaged scrolls. After the many hurdles on the road since that time, the scrolls lay before me, looking as brilliant as the day they were first made.

For the exhibition, a special display case was produced so that the two scrolls could be exhibited in their entirety unrolled. Under the display glass, the scrolls looked so vivid and colourful that they hardly appeared like material dating from the seventeenth century. This was clearly restoration work of the very highest order. I was simply astounded.

On May 12, three days before the "Rebirth of Masterpieces" exhibition was due to open, there was a preview for the people working on the exhibition. Each curator from the different museums in Europe and the US wandered around the exhibition, quite dumbstruck in astonishment at how superbly their pieces had been restored. As they returned to reality, some asked for small changes in the captioning, or an adjustment in the height of a hanging scroll. As before any opening, everyone was tense and anxious to make sure everything was perfect.

On the day of the official opening, I met up with Dr Michael Ryan, the Director of the Chester Beatty Library, at his hotel, and together we headed to the Tokyo National Museum in Ueno. We had been informed that the Emperor and Empress would be paying a visit to the exhibition before the official opening. So we were all gathered there, around eight o'clock, including the TV crew who had been following me. The director of the Tokyo National Museum, Professor Ikuo Hirayama, the

head of the Agency for Cultural Assets, and other distinguished guests lined up to welcome the Imperial Couple. Behind them stood the heads of the various restoration studios, key players behind the scenes.

As the car bringing the Imperial couple pulled into the driveway in the gentle drizzle, Professor Hirayama and the director of the museum went out to greet the Emperor and Empress. They escorted them into the museum and then moved from one painting to another. Professor Hirayama introduced each masterpiece that had been brought in a state of disrepair from either the US or Europe, and was now restored to its original beauty for the first time in centuries. Each curator stood by his or her exhibit, and Professor Hirayama relayed messages or questions from the Imperial couple. The time passed quickly, as it does when there is tension, yet everything was outwardly very calm. At the very rear of the exhibition hall, Dr Ryan and I stood beside the large display case. After a long time, the Imperial couple finally made their way to our case. As Professor Hirayama started to explain, "From Dublin, this is . . ." the Imperial couple cut across, beaming, "Congratulations, Mrs Ushioda!" As I made the deepest bow of gratitude, I recalled their words from ten years earlier when, as Crown Prince and Princess, they had told me in the Chester Beatty Library, "Please take good care of them, Mrs Ushioda." I began the explanation of each scene of the scroll, and as I moved through them, a timekeeper whispered in my ear to pick up the pace. But I could not force the pace of the Imperial couple, who stopped at every scene, enjoying each immensely.

This is the very last scene of the TV programme, "Beyond Time and Space." Although some twenty years have passed since then, the memory of this still remains with me.

The TV programme was broadcast later that same year throughout Japan, and a recording of the programme was used for a special lecture on art history in Japan at a private college.

I only knew of this when a thick envelope arrived in the post at my Dublin home. Inside were one hundred and forty one letters from the students who had watched the video, some of whom were studying Japanese literature, while others were majoring in different areas of the liberal arts. From the letters it became clear that the lecturer was an art specialist working at the Tokyo National Museum. I was surprised and gladdened to see that almost a dozen of the students had actually seen the "Rebirth of Masterpieces" exhibition in May. Some of the students had not just written an appreciation of the restoration process, but had included a researched report on verso painting that went beyond what the video had covered. Many wrote that their interest in the Chōgonka Scroll had been sparked as a result of the programme. This truly showed the power of TV. Even more delightful was when I learned that quite a few of the students were interested in studying to become museum curators, and wanted to work abroad to take care of Japanese artworks and learn restoration work from scratch . . . As I read these letters, I felt a sense of gratitude growing inside me, and I was glad that I had taken the plunge and agreed to help make the TV programme. I still keep these letters at home.

Sometime later, I heard that this video was used in some other colleges too, for a course on picture scrolls. Professor Kazuaki Komine, my long-time teacher and friend, recently sent me an email:

"I watched the video with my students at the end of my class on picture scrolls. It was part of the summer seminar at Kyoto University. As I always use this video to teach picture scrolls, it feels like I see you in person very often. Students are always impressed with the intricate restoration process and also your life. To me the programme brings back a lot of memories, so I watch it with personal interest as well."

Chapter 24

The Chester Beatty Library Catalogue by the National Institute of Japanese Literature

In the chapter "Presenting Nara Ehon to the World," I explained how the Sorimachi Catalogue of the Chester Beatty Library Japanese collection had been produced. The catalogue had been published at Mr Sorimachi's own expense in 1979. Later, in 1988, when the "Ireland's Chester Beatty Collection: Tales of Japan," or what I called the "Homecoming Exhibition," was held in Tokyo, Kobe, and Nagoya, an exhibition catalogue for the selected exhibits had been produced. As this exhibition had featured on TV, the fame of the library's collection had spread throughout Japan. Some years later, in 1993, Kodansha published a series of richly bound large-sized books, *Japanese Art: The Great European Collections*, giving exclusive coverage to the Chester Beatty Library in the fifth volume. While editing this volume got started, the National Institute of Japanese Literature (NIJL), a major centre of Japanese literature research, decided to produce a new catalogue of the Japanese collection of the Chester Beatty Library. This would be called *The Descriptive Catalogue of Japanese Illustrated Manuscripts and Printed Books in the Chester Beatty Library*.

The story began when a delegation from the NIJL travelled to Paris in early September, 1990. There were two researchers and some assistants in the group, and the purpose was to conduct some academic research on Japanese literature during their one-week stay. This was the first time that the institute had conducted research in Europe. I imagine that Professor

Jacqueline Pigeot of University Paris Diderot: Paris 7, who was then a visiting professor at the NIJL, might have influenced these arrangements. The two researchers started their survey focusing on the famous Duerre Collection and Nara ehon at the Bibliothèque Nationale de France. They soon came up against a problem—they were limited in the number of books they could access per day, and this restricted their progress. They had intended to conduct an intensive investigation in a very short time. So they wondered whether they might need to return the following year to continue the survey.

Among the delegates was Dr Satoru Sato, then assistant professor at Jissen Women's College, who was accompanying the two researchers as an assistant. Dr Sato left the delegation to travel to the US, and then stopped over in Ireland on his way back, as recommended by his boss, Professor Miya. Professor Miya was very familiar with the Chester Beatty collection since the first Nara Ehon Conference in 1978, and he had been a great supporter of the "Homecoming Exhibition" held at the Suntory Museum. Dr Sato spent some time studying at the Chester Beatty Library, and I helped him by fetching the materials he had found interesting in the Sorimachi Catalogue. During breaks, when we were chatting, I told him that I felt the catalogue had some inadequacies, as it had been prepared in a rushed timescale. I also mentioned some of the questions that had arisen since its publication. Dr Sato forwarded these questions on to the team still in Paris. A few days later, I received a courteous letter from one of the researchers, Dr Kazuaki Komine, then assistant professor at the NIJL. In the letter he wrote that the NIJL wished to conduct a survey of the entire CBL Japanese collection in order to compile a descriptive catalogue.

I was quite delighted by this offer, yet felt a little uneasy about the implications of this plan. I was unsure if the board of trustees or the library director would give their approval

easily. On the other hand, if the Sorimachi Catalogue was to be improved upon, there was no better group of experts than the NIJL to carry out the work. Accordingly, I spent considerable time in preparing a good formal application to the board to ask them for their approval. And, to my joy, the board granted permission very quickly, not even waiting until the next scheduled meeting. On the same day that I received approval, I wrote to Dr Komine to tell him the great news.

In the following year, 1991, there was more good news. The NIJL had received a supplementary budget for it to continue its work, even though the Gulf War had just broken out. A group of five NIJL researchers, including Dr Komine, travelled to Ireland for the first time to conduct a comprehensive survey of the works in the library's Japanese collection. In the following year, the group came back to continue their work, this time switching attention to the few dozen pieces that had been omitted from the Sorimachi Catalogue. Their work finally finished in 1993, and they produced a summary of their four-year examination. In 1995, the investigation broadened to include a wider range of researchers, some from NIJL and others from different institutes. Each was assigned to write a section of the catalogue according to their area of expertise.

Finally, in 2002, the NIJL catalogue was published with the title *The Descriptive Catalogue of Japanese Illustrated Manuscripts and Printed Books in the Chester Beatty Library*. It consisted of two volumes and included an English narrative as well. In the ten years or so that the NIJL project had taken, the Chester Beatty Library too had undergone big changes. The board of trustees welcomed a new head, as well as a new director of the library, and a new curator was appointed for the East Asian Collections. Above all, in 2000, on the 125th anniversary of the birth of Sir Chester Beatty, the library relocated to a newly renovated building exclusively designed to house it. This was in the premises of Dublin Castle, in the very centre of the city.

I had started to work in the library as a volunteer in 1970, and had received a permanent position ten years later. Until I retired, the place I had spent my twenty-six years was a small library with a gallery near Chester Beatty's big mansion that was situated in a prestigious residential suburb of Dublin. This was the place where I had carried out all my work, so I was quite overcome with emotion when the library moved.

In late 2011, as I was revising a draft of this chapter, a friend sent me a magazine issue. It was the January 2012 issue of *Books*, a specialist periodical. In the issue, I found an essay written by Dr Kazuaki Komine, who was now a professor at Rikkyo University, about his first visit to the Chester Beatty Library in 1991. He had been a great teacher and support for me. I hope he doesn't mind if I quote from his article:

> For my own experience, it was my visit to the Chester Beatty Library that first drew me powerfully to picture scrolls . . . there I was able to see different genres of picture scrolls, including Nara ehon, during the survey. I became instantly possessed by their charms and this has stayed with me as a kind of picture-scroll mania.

I always recalled fondly the day Dr Komine, as a young researcher, had first set foot in the library. It seemed that he too had a special place in his heart for the Chester Beatty Library. When I read this, I felt a deep sense of connection through time and space.

Chapter 25

Nara Ehon Conference in Dublin 2008

In March 2008, the Nara Ehon International Research Conference returned to Dublin. It was thirty years after the first conference was held in the Chester Beatty Library in Dublin. During that time, a number of Japanese art objects that had lain unnoticed in the library had been brought to light by different researchers, and given the recognition they deserved. In the area of Nara ehon, researchers like Professor Tōru Ishikawa of Keio University had made big advances to contribute to their understanding and recognition. In Japan, various museums now hold a special exhibition with a focus on Nara ehon. Academically, the Nara ehon International Research Organization has been newly formed under the leadership of Professor Ishikawa, supported by Keio University. Their conferences have been held in Japan and overseas. This time, Dublin was picked as a venue for the conference.

Around this time of year, colleges and universities in Japan have a spring break. As a result, more researchers were able to travel to Ireland. However, in Ireland, it coincided with the Easter holidays that year. During this sacred week, many security guards and curators would take time off, and the library itself would be closed on most days. When I received the request from Japan, I immediately went to the library to discuss this with the Director, Dr Michael Ryan, and the curator, Dr Shane McCausland. I myself had already retired from the library in 1996, and worked as an occasional volunteer. Dr McCausland was a newly appointed curator in charge of the East Asian Collections.

I knew that Easter was as important as Christmas in Ireland, so I had it in the back of my mind that it might not be possible to hold the conference as it would disrupt many holiday plans. To my surprise and joy, the Chester Beatty staff, including the director and curators, willingly agreed to this hesitant request. I was deeply moved to receive such warm support. Everyone immediately started on the various preparations, including arranging security staff, booking conference rooms as well as seminar rooms. They even secured a grand hotel function room for the night of the opening reception. The support provided by the library far exceeded my expectation, and I was delighted and still feel thankful for it now.

Finally the conference took place. At the opening ceremony, Professor Ishikawa, the chairperson, delivered an opening speech, followed by welcoming speeches by Dr Ryan, the director of the library, and Dr McCausland. Thanks to a translation provided by one of the Japanese participants, the Chester Beatty Library's warm welcome was well conveyed to the Japanese delegation. The press and cultural officer represented the Japanese embassy, and he gave a congratulatory speech both in English and Japanese.

As I checked the list of participants, I found that only two of us had participated in the original Dublin conference: the other person was Dr Gensei Tokue, who had then become professor emeritus at Kokugakuin University. This fact made me feel slightly sad. As I thought about it, I realized that many of the participants in that first conference had already been approaching retirement age, and quite a few had passed away. The participants in this conference were the next generation of researchers, who had started their work under the guidance of that earlier generation.

There was a HUMI (Humanities Media Interface) project team from Keio University participating. This project had been established to record precious documents digitally, and they

had been working on the digitization of the library's Nara ehon
and picture scrolls since 2004.

Additionally there were attendees from major universities
and colleges throughout Japan. The conference had so many
different enthusiastic presentations and discussions that it
pushed the closing time by a considerable margin each day.

A symposium was held in the afternoon of the first day with
the theme "Past, Present, and Future of the research on the
Chester Beatty Library Japanese Book Collection." Professor
Ishikawa chaired the session, and the panellists included
Professor Tokue, Professor Komine, others, and me.

During the breaks from the sessions, the Chester Beatty
collections were available for viewing. Some researchers stayed
long after the conference was over to conduct further study.

As for holding the conference over the Easter holiday, the
only slight drawback was that, as one researcher was surprised to
discover, it was not possible to enjoy a pint of draught Guinness
on Good Friday as the pubs remain closed.

Chapter 26

From Kyoto, April 2013

A SPECIAL EXHIBITION, "KANO Sanraku & Sansetsu" was to be held at the Kyoto National Museum in 2013. I had an intense desire to see this exhibition of works of the Kyoto Kano School. I flew again to Japan from the very western edge of Europe.

First I would like to quote from a piece on the Chōgonka Scroll by Dr Yoshiya Yamashita from then Kyoto National Museum, taken from the exhibition catalogue.

> It is this Chōgonka Scroll that splendidly visualises this tragic love, which unfolds in scenes over the twenty meter length of painting, with fantastic plot development and changes of pace. Elegant yet brilliant colouring using high quality pigments as well as the most elaborate miniature painting style make this a jewel of scrolls. It amply exemplifies Sansetsu's skill and unrivalled sense of creativity . . . Amongst the various Chōgonka works that exist today, this is the only work where the painter has been identified, showing his distinctive and elaborate craftsmanship of design, content, and configuration. The same degree of density can be found in his other work, Waterfowl by the Snowy Shore (Settei-Suikin-zu) although this is in a form of a screen . . .

This comment by Dr Yamashita felt like a true reward for me, after enduring the difficulties I had undergone and overcome while studying the Chōgonka Scroll since its rediscovery over

forty years earlier. Back in the hotel room in Kyoto, I read and reread, in excitement, till late in the night. This masterpiece that Sir Chester Beatty had purchased in his late years reflects his excellent sense of colour and inclination for miniature painting as well as a deep interest in gem-like objects. These had been principles he held on to throughout his life.

It was one year previously that I had found out that the Chōgonka Scroll was to be exhibited in Kyoto. At the time, the library was hosting an exhibition of the Picture Scroll "Tale of the Bamboo Cutter," which had just been restored by a studio in Leiden, Netherlands. Even though I had been in retirement for over fifteen years, I was included in the various events relating to the exhibition, such as providing a guide and giving some lectures. I overheard that Dr Yoshiya Yamashita from the Kyoto National Museum had visited the library in preparation for a special exhibition to be held in Kyoto. A few decades earlier when I had started my studies of the Chōgonka, I recall Professor Satoru Sakakibara had suggested I should consult with Dr Yamashita, the foremost expert on the Kyoto Kano School. And now this top researcher had just visited the library. I soon realized that this work of art that I had spent so much energy and time on was about to be exhibited in Kyoto. Just thinking about it gave me a shiver of excitement, and this burning desire to see the Scroll in Kyoto began.

Six months or so later, I wrote a Christmas card to Mr Mitsuro Aoyagi, an old friend who used to write for the *Asahi Shimbun* Newspaper. I mentioned the forthcoming Kyoto exhibition briefly. He emailed me back very quickly and excitedly, urging that we should go to see the exhibition together. When he had been originally writing a series of articles on the history of Japanese art masterpieces for the Sunday editions of the *Asahi Shimbun* Newspaper, he had travelled to Ireland to cover the Chōgonka Scroll. During his stay in Dublin, he came to my home, and together with my husband, we enjoyed good

conversation until late at night. Although we had continued to exchange mails after his retirement, his insistent and enthusiastic invitation was unexpected and welcome; I almost forgot about my age and frailty.

Mr Aoyagi forwarded to me very precise travel plans which ranged from bullet train schedules to information about a suitable hotel in Kyoto. Convinced by his kindness, I took the plunge and decided to travel to Kyoto.

After the long journey, I arrived in Tokyo on April 8 and made my way as planned to Kyoto. On the following day, Mr Aoyagi and I drove through the old Imperial City by taxi, and headed for the Kyoto National Museum. As we travelled, we spent the time chatting; there was a lot of catching-up to do. We arrived at the Museum at around one o'clock. There was a line of gorgeous cherry trees still in blossom at the nearby Sanjusangendo temple; they appeared to welcome us. Using my cane, I cheerfully started to make my way toward the museum entrance. Mr Aoyagi stopped me to take a few photographs with the museum as a backdrop. Later, during a break, he would email those photographs to my worried husband in Dublin. Later, when I found out that he had done this, I was filled with gratitude for his consideration.

As we stepped into the museum, there was a little tension of expectation. However that soon melted away as different emotions took over. On the wall of the first exhibition room, there were eight sliding door panels of "The Red Plum" (Kobai-zu-fusuma) and "Peonies" (Botanzu-fusuma), pieces that I had only ever seen in catalogues. A pair of four sliding door panels "The Old Plum" (Robai-zu-fusuma) follow these. These were so brilliant that I stood and almost forgot to move on.

When I visit a museum, I usually take an initial view of an exhibit, then I read whatever major caption is provided and then return to absorb and admire the piece. In this way I made my way through each of the exhibits, moving from one room

to the next. The final set of rooms was the main purpose of my visit, the Chōgonka Scroll. Each of the two scrolls was unrolled completely to extend over ten metres, and so two rooms were dedicated to the Chester Beatty Chōgonka Scroll. As I looked down at the scroll unfurled below me in the long glass case, I looked at the detail of each scene, filled with dignity, grace, and spirit. I found myself singing Bai Juyi's poem, as over the years I had come to learn it by heart, and my eyes welled up with tears. Mr Aoyagi did not say a word. Without any haste whatever, I admired each scene on each scroll. Finally we sat down on the sofa in the corner of the second room, still silent. There was no need for words.

It was past four in the afternoon, and we had tea with the director of the Museum at his office.

References

Alfred Chester Beatty and Ireland 1950-1968: A Study in Cultural Politics, Brian P. Kennedy. The Glendale Press, 1988.

The White Pony: An Anthology of Chinese Poetry from the Earliest Times to the Present Day, Newly Translated. Ed. Robert Payne. John Day Company, 1947.

Chinese Romance from a Japanese Brush: Kano Sansetsu's Chōgonka Scrolls in the Chester Beatty Library, Shane McCausland, Matthew P. McKelway, Scala Publishers Ltd., 2009.

Glossary

Chester Beatty Library
Located in Dublin, the Library houses excellent collections of manuscripts, prints, miniature paintings, and other items from across Asia and other regions. Named after the American mining magnate Sir Alfred Chester Beatty, who bequeathed his collections.

Surimono prints
Privately commissioned woodblock prints made from the late eighteenth through the early nineteenth century, most of these prints include "Kyoka" verse and an image produced with excellent craftsmanship.

Nara ehon
Generally refers to handmade copies of colourfully illustrated pictures and writing of Japanese folktales, classic narratives, and others. These are in the form of scrolls or booklets, produced from the sixteenth to the early eighteenth century.

Chōgonka
Japanese name of the Chinese narrative poem *Everlasting Sorrows* written by Bai Juyi in the early ninth century. It depicts a famous Chinese legend of the tragic love between Xuanzong, the sixth Emperor of the Tang Dynasty, and Yang Guifei, a lady of peerless beauty.

The Chōgonka Scroll
A set of two scrolls painted during the seventeenth century by Sansetsu Kano. It illustrates a Chinese narrative poem, *Chōgonka*. The Chester Beatty Library version is of excellent quality, making use of verso painting (*ura-zaishiki*) technique, and is regarded as the only "silk" version of "The Chōgonka Scroll" that exists today.

Ura-zaishiki
A verso painting technique used to create complex colour effects by painting from both the front and back.

The Tale of Genji
Eleventh-century novel by Murasaki Shibuku, a lady-in-waiting at the Imperial Court in Kyoto. Often considered the first great novel in world literature, it consists of fifty-four chapters, which recount the life and romances of Prince Genji and his contemporaries in remarkably elegant style.

A Brief Guide to Japanese Historical Periods
Mentioned in the Text

Heian Period	AD 794–circa 1185.
Muromachi Period	AD 1336–circa 1573.
Edo Period	AD circa 1603–1868.
Meiji Period	AD 1868–1912.
Taishō Period	AD 1912–1926.
Showa Period	AD 1926–1989.

Yoshiko Ushioda was born in 1931 in Mito, Japan, and moved to Dublin in 1960. In 1970, she began volunteering at the Chester Beatty Library, and was promoted to curator of the Japanese Arts Collection in 1980. She retired in 1996, and currently lives in Dublin with her huband.

Etsuko Kanamori was born in 1959 in Nagasaki and has worked as a translator for Ericsson Japan in Fukuoka and Shin-Yokohama. She currently lives in Dublin, Ireland.

Translator's Acknowledgements

The translation of this book could not have been completed without the huge support provided by Mr. Kazuaki and Dr. Ema Ushioda. Mrs. Yoshiko and Dr. Satoshi Ushioda made generous contributions to the project as well. I am hugely indebted to all the members of the Ushioda family.

Dr. Declan M. Downey most kindly reviewed the manuscript and provided invaluable advice as well as a very insightful foreword. I am also thankful to Director Fionnuala Croke, Dr. Mary Redfern and other staff at the Chester Beatty Library for their expertise and support. At Dalkey Archive Press, special thanks goes to Dr. John O'Brien, Mr. Jake Snyder, Mr. Nathan Redman, and Mr. Alex Andriesse for believing in this project. I wish to thank Mrs. Akiko Sato for precious and sincere advice and support as a friend.

Last but not least, my heartfelt gratitude goes to my in-house adviser, great listener and helper, Espen.

Etsuko Kanamori

MICHAL AJVAZ, *The Golden Age.*
The Other City.
PIERRE ALBERT-BIROT, *Grabinoulor.*
YUZ ALESHKOVSKY, *Kangaroo.*
SVETLANA ALEXIEVICH, *Voices from Chernobyl.*
FELIPE ALFAU, *Chromos.*
Locos.
JOAO ALMINO, *Enigmas of Spring.*
IVAN ÂNGELO, *The Celebration.*
The Tower of Glass.
ANTÓNIO LOBO ANTUNES, *Knowledge of Hell.*
The Splendor of Portugal.
ALAIN ARIAS-MISSON, *Theatre of Incest.*
JOHN ASHBERY & JAMES SCHUYLER, *A Nest of Ninnies.*
GABRIELA AVIGUR-ROTEM, *Heatwave and Crazy Birds.*
DJUNA BARNES, *Ladies Almanack.*
Ryder.
JOHN BARTH, *Letters.*
Sabbatical.
Collected Stories.
DONALD BARTHELME, *The King.*
Paradise.
SVETISLAV BASARA, *Chinese Letter.*
Fata Morgana.
In Search of the Grail.
MIQUEL BAUÇÀ, *The Siege in the Room.*
RENÉ BELLETTO, *Dying.*
MAREK BIENCZYK, *Transparency.*
ANDREI BITOV, *Pushkin House.*
ANDREJ BLATNIK, *You Do Understand.*
Law of Desire.
LOUIS PAUL BOON, *Chapel Road.*
My Little War.
Summer in Termuren.
ROGER BOYLAN, *Killoyle.*
IGNÁCIO DE LOYOLA BRANDÃO, *Anonymous Celebrity.*
Zero.
BRIGID BROPHY, *In Transit.*
The Prancing Novelist.

GABRIELLE BURTON, *Heartbreak Hotel.*
MICHEL BUTOR, *Degrees.*
Mobile.
G. CABRERA INFANTE, *Infante's Inferno.*
Three Trapped Tigers.
JULIETA CAMPOS, *The Fear of Losing Eurydice.*
ANNE CARSON, *Eros the Bittersweet.*
ORLY CASTEL-BLOOM, *Dolly City.*
LOUIS-FERDINAND CÉLINE, *North.*
Conversations with Professor Y.
London Bridge.
HUGO CHARTERIS, *The Tide Is Right.*
ERIC CHEVILLARD, *Demolishing Nisard.*
The Author and Me.
MARC CHOLODENKO, *Mordechai Schamz.*
EMILY HOLMES COLEMAN, *The Shutter of Snow.*
ERIC CHEVILLARD, *The Author and Me.*
LUIS CHITARRONI, *The No Variations.*
CH'OE YUN, *Mannequin.*
ROBERT COOVER, *A Night at the Movies.*
STANLEY CRAWFORD, *Log of the S.S. The Mrs Unguentine.*
Some Instructions to My Wife.
RALPH CUSACK, *Cadenza.*
NICHOLAS DELBANCO, *Sherbrookes.*
The Count of Concord.
NIGEL DENNIS, *Cards of Identity.*
PETER DIMOCK, *A Short Rhetoric for Leaving the Family.*
ARIEL DORFMAN, *Konfidenz.*
COLEMAN DOWELL, *Island People.*
Too Much Flesh and Jabez.
RIKKI DUCORNET, *Phosphor in Dreamland.*
The Complete Butcher's Tales.
RIKKI DUCORNET (cont.), *The Jade Cabinet.*
The Fountains of Neptune.
WILLIAM EASTLAKE, *Castle Keep.*
Lyric of the Circle Heart.
JEAN ECHENOZ, *Chopin's Move.*

STANLEY ELKIN, *A Bad Man*.
The Dick Gibson Show.
The Franchiser.

FRANÇOIS EMMANUEL, *Invitation to a Voyage*.

SALVADOR ESPRIU, *Ariadne in the Grotesque Labyrinth*.

LESLIE A. FIEDLER, *Love and Death in the American Novel*.

JUAN FILLOY, *Op Oloop*.

GUSTAVE FLAUBERT, *Bouvard and Pécuchet*.

JON FOSSE, *Aliss at the Fire*.
Melancholy.
Trilogy.

FORD MADOX FORD, *The March of Literature*.

MAX FRISCH, *I'm Not Stiller*.
Man in the Holocene.

CARLOS FUENTES, *Christopher Unborn*.
Distant Relations.
Terra Nostra.
Where the Air Is Clear.
Nietzsche on His Balcony.

WILLIAM GADDIS, JR., *The Recognitions*.
JR.

JANICE GALLOWAY, *Foreign Parts*.
The Trick Is to Keep Breathing.

WILLIAM H. GASS, *Life Sentences*.
The Tunnel.
The World Within the Word.
Willie Masters' Lonesome Wife.

GÉRARD GAVARRY, *Hoppla! 1 2 3*.

ETIENNE GILSON, *The Arts of the Beautiful*.
Forms and Substances in the Arts.

C. S. GISCOMBE, *Giscome Road*.
Here.

DOUGLAS GLOVER, *Bad News of the Heart*.

WITOLD GOMBROWICZ, *A Kind of Testament*.

PAULO EMÍLIO SALES GOMES, *P's Three Women*.

GEORGI GOSPODINOV, *Natural Novel*.

JUAN GOYTISOLO, *Juan the Landless*.
Makbara.
Marks of Identity.

JACK GREEN, *Fire the Bastards!*

JIŘÍ GRUŠA, *The Questionnaire*.

MELA HARTWIG, *Am I a Redundant Human Being?*

JOHN HAWKES, *The Passion Artist*.
Whistlejacket.

ELIZABETH HEIGHWAY, ED., *Contemporary Georgian Fiction*.

AIDAN HIGGINS, *Balcony of Europe*.
Blind Man's Bluff.
Bornholm Night-Ferry.
Langrishe, Go Down.
Scenes from a Receding Past.

ALDOUS HUXLEY, *Antic Hay*.
Point Counter Point.
Those Barren Leaves.
Time Must Have a Stop.

JANG JUNG-IL, *When Adam Opens His Eyes*

DRAGO JANČAR, *The Tree with No Name*.
I Saw Her That Night.
Galley Slave.

MIKHEIL JAVAKHISHVILI, *Kvachi*.

GERT JONKE, *The Distant Sound*.
Homage to Czerny.
The System of Vienna.

JACQUES JOUET, *Mountain R*.
Savage.
Upstaged.

JUNG YOUNG-MOON, *A Contrived World*.

MIEKO KANAI, *The Word Book*.

YORAM KANIUK, *Life on Sandpaper*.

ZURAB KARUMIDZE, *Dagny*.

PABLO KATCHADJIAN, *What to Do*.

JOHN KELLY, *From Out of the City*.

HUGH KENNER, *Flaubert, Joyce and Beckett: The Stoic Comedians*.
Joyce's Voices.

DANILO KIŠ, *The Attic*.
The Lute and the Scars.
Psalm 44.
A Tomb for Boris Davidovich.

ANITA KONKKA, *A Fool's Paradise*.

GEORGE KONRÁD, *The City Builder.*

TADEUSZ KONWICKI, *A Minor Apocalypse.*

The Polish Complex.

ELAINE KRAF, *The Princess of 72nd Street.*

JIM KRUSOE, *Iceland.*

AYSE KULIN, *Farewell: A Mansion in Occupied Istanbul.*

EMILIO LASCANO TEGUI, *On Elegance While Sleeping.*

ERIC LAURRENT, *Do Not Touch.*

VIOLETTE LEDUC, *La Bâtarde.*

LEE KI-HO, *At Least We Can Apologize.*

EDOUARD LEVÉ, *Autoportrait.*

Suicide.

MARIO LEVI, *Istanbul Was a Fairy Tale.*

DEBORAH LEVY, *Billy and Girl.*

JOSÉ LEZAMA LIMA, *Paradiso.*

OSMAN LINS, *Avalovara.*

The Queen of the Prisons of Greece.

ALF MACLOCHLAINN, *Out of Focus.*

Past Habitual.

RON LOEWINSOHN, *Magnetic Field(s).*

YURI LOTMAN, *Non-Memoirs.*

D. KEITH MANO, *Take Five.*

MINA LOY, *Stories and Essays of Mina Loy.*

MICHELINE AHARONIAN MARCOM, *The Mirror in the Well.*

BEN MARCUS, *The Age of Wire and String.*

WALLACE MARKFIELD, *Teitlebaum's Window.*

To an Early Grave.

DAVID MARKSON, *Reader's Block.*

Wittgenstein's Mistress.

CAROLE MASO, *AVA.*

HISAKI MATSUURA, *Triangle.*

LADISLAV MATEJKA & KRYSTYNA POMORSKA, EDS., *Readings in Russian Poetics: Formalist & Structuralist Views.*

HARRY MATHEWS, *Cigarettes.*

The Conversions.

The Human Country.

The Journalist.

My Life in CIA.

Singular Pleasures.

The Sinking of the Odradek.

Stadium.

Tlooth.

JOSEPH MCELROY, *Night Soul and Other Stories.*

ABDELWAHAB MEDDEB, *Talismano.*

GERHARD MEIER, *Isle of the Dead.*

HERMAN MELVILLE, *The Confidence-Man.*

AMANDA MICHALOPOULOU, *I'd Like.*

STEVEN MILLHAUSER, *The Barnum Museum.*

In the Penny Arcade.

RALPH J. MILLS, JR., *Essays on Poetry.*

CHRISTINE MONTALBETTI, *The Origin of Man.*

Western.

NICHOLAS MOSLEY, *Accident.*

Assassins.

Catastrophe Practice.

Hopeful Monsters.

Imago Bird.

Natalie Natalia.

Serpent.

WARREN MOTTE, *Fiction Now: The French Novel in the 21st Century.*

Oulipo: A Primer of Potential Literature.

GERALD MURNANE, *Barley Patch.*

Inland.

YVES NAVARRE, *Our Share of Time.*

Sweet Tooth.

DOROTHY NELSON, *In Night's City.*

Tar and Feathers.

WILFRIDO D. NOLLEDO, *But for the Lovers.*

BORIS A. NOVAK, *The Master of Insomnia.*

FLANN O'BRIEN, *At Swim-Two-Birds.*

The Best of Myles.

The Dalkey Archive.

The Hard Life.

The Poor Mouth.

The Third Policeman.

CLAUDE OLLIER, *The Mise-en-Scène.*

Wert and the Life Without End.

PATRIK OUŘEDNÍK, *Europeana.*
 The Opportune Moment, 1855.
BORIS PAHOR, *Necropolis.*
FERNANDO DEL PASO, *News from
 the Empire.*
 Palinuro of Mexico.
ROBERT PINGET, *The Inquisitory.*
 Mahu or The Material.
 Trio.
MANUEL PUIG, *Betrayed by Rita Hayworth.*
 The Buenos Aires Affair.
 Heartbreak Tango.
RAYMOND QUENEAU, *The Last Days.*
 Odile.
 Pierrot Mon Ami.
 Saint Glinglin.
ANN QUIN, *Berg.*
 Passages.
 Three.
 Tripticks.
ISHMAEL REED, *The Free-Lance
 Pallbearers.*
 The Last Days of Louisiana Red.
 Ishmael Reed: The Plays.
 Juice!
 The Terrible Threes.
 The Terrible Twos.
 Yellow Back Radio Broke-Down.
RAINER MARIA RILKE,
 The Notebooks of Malte Laurids Brigge.
JULIÁN RÍOS, *The House of Ulysses.*
 Larva: A Midsummer Night's Babel.
 Poundemonium.
ALAIN ROBBE-GRILLET, *Project for a
 Revolution in New York.*
 A Sentimental Novel.
AUGUSTO ROA BASTOS, *I the Supreme.*
DANIËL ROBBERECHTS, *Arriving in
 Avignon.*
JEAN ROLIN, *The Explosion of the
 Radiator Hose.*
OLIVIER ROLIN, *Hotel Crystal.*
ALIX CLEO ROUBAUD, *Alix's Journal.*
JACQUES ROUBAUD, *The Form of
 a City Changes Faster, Alas, Than the
 Human Heart.*

The Great Fire of London.
Hortense in Exile.
Hortense Is Abducted.
*Mathematics: The Plurality of Worlds of
 Lewis.*
Some Thing Black.
RAYMOND ROUSSEL, *Impressions of
 Africa.*
VEDRANA RUDAN, *Night.*
GERMAN SADULAEV, *The Maya Pill.*
TOMAŽ ŠALAMUN, *Soy Realidad.*
LYDIE SALVAYRE, *The Company of Ghosts.*
LUIS RAFAEL SÁNCHEZ, *Macho
 Camacho's Beat.*
SEVERO SARDUY, *Cobra & Maitreya.*
NATHALIE SARRAUTE, *Do You Hear
 Them?*
 Martereau.
 The Planetarium.
STIG SÆTERBAKKEN, *Siamese.*
 Self-Control.
 Through the Night.
ARNO SCHMIDT, *Collected Novellas.*
 Collected Stories.
 Nobodaddy's Children.
 Two Novels.
ASAF SCHURR, *Motti.*
GAIL SCOTT, *My Paris.*
JUNE AKERS SEESE,
 Is This What Other Women Feel Too?
BERNARD SHARE, *Inish.*
 Transit.
VIKTOR SHKLOVSKY, *Bowstring.*
 Literature and Cinematography.
 Theory of Prose.
 Third Factory.
 Zoo, or Letters Not about Love.
PIERRE SINIAC, *The Collaborators.*
KJERSTI A. SKOMSVOLD,
 The Faster I Walk, the Smaller I Am.
JOSEF ŠKVORECKÝ, *The Engineer of
 Human Souls.*
GILBERT SORRENTINO, *Aberration of
 Starlight.*
 Blue Pastoral.
 Crystal Vision.

Imaginative Qualities of Actual Things.
Mulligan Stew.
Red the Fiend.
Steelwork.
Under the Shadow.
ANDRZEJ STASIUK, *Dukla.*
Fado.
GERTRUDE STEIN, *The Making of Americans.*
A Novel of Thank You.
PIOTR SZEWC, *Annihilation.*
GONÇALO M. TAVARES, *A Man: Klaus Klump.*
Jerusalem.
Learning to Pray in the Age of Technique.
LUCIAN DAN TEODOROVICI, *Our Circus Presents...*
NIKANOR TERATOLOGEN, *Assisted Living.*
STEFAN THEMERSON, *Hobson's Island.*
The Mystery of the Sardine.
Tom Harris.
JOHN TOOMEY, *Sleepwalker.*
Huddleston Road.
Slipping.
DUMITRU TSEPENEAG, *Hotel Europa.*
The Necessary Marriage.
Pigeon Post.
Vain Art of the Fugue.
La Belle Roumaine.
Waiting: Stories.
ESTHER TUSQUETS, *Stranded.*
DUBRAVKA UGRESIC, *Lend Me Your Character.*
Thank You for Not Reading.
TOR ULVEN, *Replacement.*
MATI UNT, *Brecht at Night.*
Diary of a Blood Donor.
Things in the Night.
ÁLVARO URIBE & OLIVIA SEARS, EDS., *Best of Contemporary Mexican Fiction.*
ELOY URROZ, *Friction.*
The Obstacles.
LUISA VALENZUELA, *Dark Desires and the Others.*
He Who Searches.

PAUL VERHAEGHEN, *Omega Minor.*
BORIS VIAN, *Heartsnatcher.*
TOOMAS VINT, *An Unending Landscape.*
ORNELA VORPSI, *The Country Where No One Ever Dies.*
AUSTRYN WAINHOUSE, *Hedyphagetica.*
MARKUS WERNER, *Cold Shoulder.*
Zundel's Exit.
CURTIS WHITE, *The Idea of Home.*
Memories of My Father Watching TV.
Requiem.
DIANE WILLIAMS, *Excitability: Selected Stories.*
DOUGLAS WOOLF, *Wall to Wall.*
Ya! & John-Juan.
JAY WRIGHT, *Polynomials and Pollen.*
The Presentable Art of Reading Absence.
PHILIP WYLIE, *Generation of Vipers.*
MARGUERITE YOUNG, *Angel in the Forest.*
Miss MacIntosh, My Darling.
REYOUNG, *Unbabbling.*
ZORAN ŽIVKOVIĆ , *Hidden Camera.*
LOUIS ZUKOFSKY, *Collected Fiction.*
VITOMIL ZUPAN, *Minuet for Guitar.*
SCOTT ZWIREN, *God Head.*

AND MORE . . .